Atget's Gardens

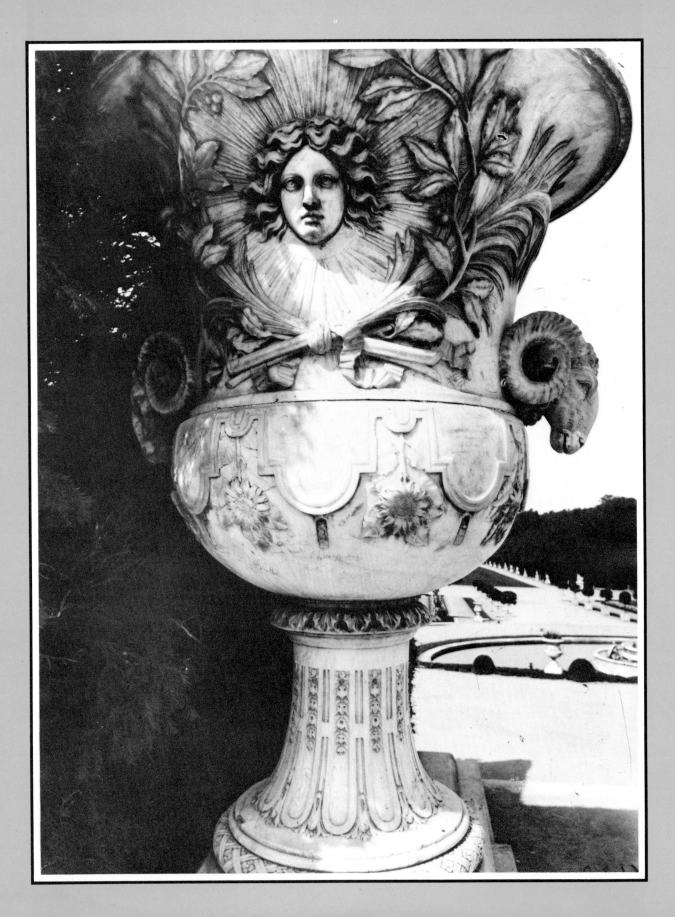

William Howard Adams

et's Gardens

gène Atget's garden photographs

n by Jacqueline Onassis

f British Architects, London

er of Photography, New York

itions Foundation, Washington

lphin Book

& Company, Inc.

New York 1979

A Doubleday/Dolphin Book

Copyright © 1979 by William Howard Adams
Introduction by Jacqueline Onassis © 1979

Designed and produced by Duobooks Inc., New York
 Format by Irwin Glusker
 Layout by Kristen Reilly

ISBN: 0-385-15320-1
Library of Congress Number: 79-7037

Contents

Introduction by Jacqueline Onassis 6

Atget 9

The Gardens

 Versailles 17

 St.-Cloud 24

 Sceaux 27

 Arcueil 31

 City Gardens 32

The Photographs 38

Notes on the Photographs 114

Acknowledgements 120

Introduction

To be able to look at the French garden through the eyes of Eugène Atget is one of the great gifts that artist has left us.

This exhibition and book mark the first time that a selection of his photographs of the royal parks and gardens of France have appeared together. Indeed, it is surprising how little of the work of this master has been published. His prints lie in buckram boxes and cardboard folders in museums' stacks or on collectors' shelves, hang on dealers' walls or are pasted matter-of-factly into the topographical albums of government archives. To see them together at last is unforgettable. His images communicate beauty, emotion, and history in powerful harmony. Each element illuminates and reinforces the other as we follow the self-effacing, obsessed photographer on his rounds winter, summer, spring, and fall, through the gardens of Versailles, Sceaux, St.-Cloud, the Tuileries, and the Luxembourg. He will find an *allée* of trees, a statue, and return to photograph it again and again, in different seasons, different years, different light. As we look at the iconography of architecture, sculpture, and fountains recorded by the honesty of Atget's vision, the ancient mysteries of the places return to haunt us. We are taken by his poetry. His conquest of us, like that of his own visible world, is complete.

Atget is celebrated for his straightforward use of the camera to document the urban scene of Paris at the turn of the century. His passionate persistence was echoed a half century later by Georges Duhamel at the Académie Française: "In the present disorder of the world, to conserve is to create." But Atget's search represented something far more profound than simply recording and preserving a disappearing world. As Susan Sontag has reminded us, "What moves people to take pictures is finding something beautiful." It was beauty that he was after, and in the gardens that is what he found.

Atget was at ease with beauty wherever he found it, in the damp city streets, among scraps of old ironwork, or on the surface glass of a shop window. But one feels that it was in the parks and gardens, recording with his camera what William H. Fox Talbot called "the injuries of time," to the marble, stone, and old trees, that he made his most soaring discoveries of beauty. It is not just the fading romance of something about to disappear that he gives us, but rather a new statement now framed within his photograph that transcends the evocative beauty of the gardens themselves.

In organizing the material, we were at first overwhelmed by the sheer quantity of Atget's garden photographs. Passages of his earliest and latest work are preoccupied with the subject. By limiting the scope of exhibition and book to those former royal domains of Paris and the Île de France that seem to have afforded the photographer the greatest fascination, especially Versailles and Sceaux, we have managed to hold our selection to seventy-seven prints.

In assembling the documents, an unforeseen pattern of visual expression seemed to emerge.

Through Atget's eyes, each of the gardens began to reveal a special character that became more evident as we proceeded. We had been concerned that the collection might appear to a viewer unfamiliar with the subjects to be an anthology of garden scenes that all came from one place. Vases, sculpture, trees, and avenues (with the exception of the romantic ruin of Sceaux) could well blend into a collage of a composite landscape, blurring the identities of each of these great garden masterpieces. Our concern evaporated, for Atget's eye chose and caught with each exposure the unique essence of each place.

In the noble sweep of the vistas of Versailles, with the sun-touched decorations everywhere, Atget seized the political as well as the aesthetic triumph of that glorious despotic creation, even though the original layout and living structure of plants and trees have undergone countless changes since the splendid century of Louis XIV.

Atget's photographs of St.-Cloud have in close-up a sensuality and in long view a stark architectural quality. The château is gone; burned and vandalized in the disastrous events of 1870–71. Atget was thirteen when the Second Empire fell. His views of the park and waterworks convey the accumulation of history at this loveliest of sites, the palace erased, heroic balustrades framing the emptiness he found.

Sceaux's visual coherence was made possible by its neglect. By 1900 "the injuries of time" had made it a mirage of history that can hardly be believed. Could the intrigues of the Duchesse du Maine, the malicious smile of Voltaire have quivered here, in this image that seems a wild Greek island with terme and tree torn by wind, in this one which shows a sorcerer's wood? The wildness has been largely corrected now by careful civic restoration, so that Atget's record of Sceaux at its greatest moment of decay is a unique historical documentation.

In the city parks we feel Atget's humanity. He photographs with tenderness and melancholy. In the Tuileries, the park chair, as French as the croissant, lies overturned beside a leering faun. In the Luxembourg, the fountain has become a family gathering place. We find these photographs troubling because we can connect to them. The time is bourgeois here, and our grandfathers sit in black serge suits along the paths laid out by kings and queens.

The royal vision lingers wherever the antique lines they imposed long ago on the landscape still survive, despite all the vicissitudes of time. Atget the *imagier* has caught that vanished past and allowed us to experience the beauty of the French garden which reaches back through a thousand years of cultivation. That he did it with another French invention and art form—the photograph—only compounds our pleasure and our admiration.

Of the art of France, Edith Wharton said that we had only to look around us and "see that the whole world is full of her spilt glory." Atget's gardens are a part of that largesse.

—Jacqueline Onassis

Atget by Berenice Abbott

Atget

His views of Paris have become a part of our mythical image of that fabled city. Our jaded eyes slide easily over their perfect composition, and our minds quickly turn to those haunting passages in Proust or Henry James. The famous streets, landmarks, churches, palaces, and hotels are still mostly there, surviving somehow in the urban chaos of the late twentieth century, giving us a superficial shock of recognition whenever we see an Atget photograph. Yet beneath their familiarity there is a remoteness of suspended time as if they were a part of some rare moment of one's life only half remembered in a dream.

Baudelaire, who hated photography and all that it stood for, on which a "squalid society hurled itself like a single Narcissus to contemplate its vulgar image," described the ideal modern artist as if he were writing of Atget himself, whom he never knew. "Observer, philosopher, *flâneur* —call him what you will; . . . he is the painter of the passing moment and all the suggestion of eternity that it contains." Someone said he photographed the deserted streets of Paris like a crime photographer for the purpose of establishing the evidence. It is hard to say what his real intentions were, for he left us little or nothing beyond his work to spin out elaborate theories. Perhaps to him his "documents"—the label he used for his photographs when negotiating their sale to the archives of the Monuments Historiques and the Bibliothèque Nationale—were just that, plain statements of documentation. Yet the intrusion of his photographs through their incomparable beauty into Baudelaire's precious realm of art, a trespasser in "the domain of the intangible and the imaginary," reveals quite a different sensibility at work.

Atget's work is his life. It was a life that we see as an extraordinary city of the imagination and projected onto a map. Given the allure of the great metropolis itself, with its streets leading to endless surprises, of old houses, doorways, reflections, trees, gardens, and statuary, the narcotic scent of its beauty drew him into its irresistible network and made him an addict. He never recovered.

Atget's passion for collecting his documents had the intensity of a child for whom things are not yet commodities and are therefore literally priceless. Rummaging through the debris of modern life and selecting his documents from the fleeting moment with his camera, they were salvaged and redeemed by his unique perception. Yet his attitude to his material was, for all of his obsession, as Jacques Rivière remarked about Proust, "without the slightest metaphysical interest, without the slightest penchant for construction, without the slightest tendency to console."

Beneath the documentary evidence of a façade of a seventeenth-century hôtel, the chiseled face on a fountain spout, the figure of Daphne, forever fleeing from Apollo on her pedestal in the Tuileries, there are other elements we now recognize as basic to the photographer's art. There are the mysterious, deep shadows that open up with infinite details when we look closely, the exploration of the quality of light falling across the stained face of the marble nymph, the worn stone surface of the urn studied at different times of the day, the tree-lined walk in the contrasts of different seasons, the two dark figures in the distance that emerge from the background behind the white goddess. There is so much there that is masked with a deceptive reality. But always there is the documentary ingredient, the apparent realism, that ensured the preservation of Atget's plates. Their lack of

pictorial rhetoric made them perfect archival material for future urban historians. It also postponed the recognition of his genius.

Near the end of his life, alone and "without heirs or progeny," he offered his collection of glass negatives to the director of the Beaux Arts: ". . . fine façades and doors, panelings, door knockers, old fountains, period stairs (wood and wrought iron). . . ." The list of so much commonplace wreckage of the past could be the contents of an eccentric junk dealer's shop and, at ten francs a plate, priced accordingly. Of course, it is true that "Atget did not know that he was Atget," as a friend later observed. How could he? He was the most unpretentious man. Yet for all his shyness, he never doubted the importance of his "Documents pour Artistes," the words of the handmade sign he placed on his apartment door at 17 *bis* rue Campagne Première in Montparnasse.

In his omniverous appropriation of the history of Paris, or at least its gelatin surface of silver bromide on thin glass plates, he fell under the spell of the parks and gardens of Versailles, St.-Cloud, Sceaux, and the city retreats of the Luxembourg, Tuileries, and the Palais Royal.

How many times strangers must have been startled by this shabby old man with his heavy camera loitering in the overgrown avenues, skeletons of Le Nôtre's endless vistas at Sceaux, or saw him huddled under the black shroud as he focused on the play of light over the still water of the basin at St.-Cloud. Nothing seemed to stop his search through the souvenirs of history in the streets, alleys, and doorways of Paris and in the former royal domains west and south of the city. His unerring instinct for the precise image guided him through that critical mass of memories buried under the banalities of daily life. His sense of *mise en scène* that we see in the view of the great sweep of Mansart's façade or of Marie Antoinette's *hameau* caught in the haunted shadows of her *jardin anglais* probably owes something to his years in the theater. For this former actor, "the visible world became the stage." These words of Man Ray's friend Berenice Abbott probably sum up as well as any that special quality of Atget's art, and nowhere more dramatically than in his image of the garden seen as an empty stage set. The way the light falls across a table or the position of a chair or vase of flowers tells us what the emotion of the first spoken lines will be. In Atget's gardens, it is the final curtain, and we are left with the silent tableau drained by the action, but with the sound of the last words still hovering in the air nearby.

Abbott says that when Atget gave up the theater at the age of forty, in 1897, deciding to learn a new profession, he used the out-of-the-way châteaux and their parks on the outskirts of the city as a studio. He could experiment with and learn to handle the new medium in the seclusion of the gardens without interference by the curious or suspicious. Not only was Atget himself a novice, of advancing age, but photography itself was still in its formative years, having developed from the single-copy daguerreotype to the multiple print during his lifetime. Leaving early in the morning and carrying his heavy bellows camera with its rectilinear lens, wood tripod, and a dozen glass plates, he would head off to some abandoned paradise—to the far reaches of the park at Versailles, the cascade near the burned-out palace of St.-Cloud, or the deserted streets around Marie de Medici's aqueduct at Arcueil—and there set up his private photography studio. The first results were pedestrian, though a straightforward pictorial record, and some of his early photographs found their way into the topographical files and scrapbooks of the Bibliothèque Nationale. Many are indistinguishable from other anonymous photographs routinely documenting obscure facets of French history. Like any beginner, he had his disasters which can be seen in some of the dull compositions at Versailles or the headless statues at the Tuileries decapitated by his camera. The lenses of his camera were immovable against the image plane, often causing him to cut off the upper part of the picture because of the converging verticals in the perspective. When it came to the paper

Coin du parc

he used for his prints, he was adamantly reactionary, refusing Man Ray's suggestion to try some of the new materials that were more permanent. When Man Ray suggested that he would like to print some of Atget's plates on a better type of paper, the photographer replied that since his photographs were only documents they would sell just as well using his old-fashioned technique and materials.

In sorting through box after box of Atget prints in Paris or at the Victoria and Albert Museum, where the collections were acquired solely for the information they held on all manner of French architectural and decorative details, I have often been struck by the isolation which seems to envelop his objects of history. Neatly labeled and classified—gates, steps, châteaux, fountains, windows—they nevertheless illuminate these minor facets of the historic landscape with a compelling light. It may have been the isolation of the seventeenth-century gardens themselves with their ancient, submerged outlines of the past, where he first perfected his techniques that inspired him to concentrate on salvaging a kind of collective memory through the camera's lens. After all, the seventeenth century had transformed all imagery into allegory, and the gardens particularly were loaded with symbolic meaning. Though denatured by time, some of these heroic allusions survived in the statuary of antique gods and goddesses hustling their ancient stories to anyone who would listen to them along the walks, in the basins, and around the fountains. Their classic forms in surreal settings fascinated the photographer.

Atget's genius, like Baudelaire's, was also allegorical. Not only the city, but the great urban and suburban parks with their hidden messages became the subject of his photographic poetry. Caught in the convulsions of nineteenth-century speculation and development, the fragile monuments, symbols, and artifacts of the community's ancient past were daily threatened. More and more old streets or even whole districts of Paris were being appropriated by Haussmann or his successors. The colony of Apollos, Hercules, Saturns, and their minions, battered and chipped, shorn of arms and heads or ignominiously written upon, were a part of the condemned Parnassus that Atget studied like an anthropologist on a field trip.

In his work Atget did not simply record the life of the city and its parks merely as it was lived, but as it was also remembered. Atget's pictures, like the pages of Proust, not only make us see and feel his immediate experience, but suffer his recollections as well. The photographs of his gardens convey to us all that has gone on in them before he set up his camera, making those events infinite as a part of our memory. It is the power of these recollections evoked in his work that guides us in deciphering his visual text.

At the beginning of his collection of essays *Contre Sainte-Beuve,* Proust's first line—"Every day I set less store on the intellect. . . . What intellect restores to us under the name of the past is not the past"—not only is a key to his novels but, in a way, a clue to Atget's approach to photography as well. The history that Atget's genius has brought to life for us depends on no cold, curious intellect. Rather it is suffused with meanings that cannot be found in the rhetorical accounts of official documents or in the memoirs of politicians or their mistresses' letters or in any of the other conventional sources where the past is presumed to be safely stored. Atget's past is found concentrated in an illusive reality of altogether different dimensions that threaten to dissolve at any moment.

Genius, of course, transcends the personality, and personal data are of little importance, but before entering Atget's gardens, a few more details might be squeezed out of what little we know. The narrow confines of his biography, however, only tend to underline its relative insignificance to the body of his great achievements.

Atget was born on February 12, 1857, at Libourne, not far from Bordeaux. Hardly thirty

years before, Niepce had produced the first photographic image. His parents died when he was young, and he was raised by an uncle until he was old enough to go to sea as a cabin boy. His education was erratic and limited, but its formal meagerness allowed him to escape the poisonous routines of provincial schooling so lethal to a creative personality. His friend André Calmette, artistic director of the Municipal Theater at Strasbourg, whose biographical letter to Berenice Abbott is a chief source of what little firsthand information we have, did not meet Atget until he came to Paris years later, so there are decades of blank pages.

Sometime in the 1880s he had taken up acting, and after appearing in provincial theaters, he moved to Paris, where he worked for the next ten years. He was not a success. Calmette said that he had "hard features" and was therefore given "third roles" until these, too, dried up. There is an undated drawing of Atget the actor dressed, presumably, for one of these roles. We see a stylish gentleman, perhaps in his late thirties, in the dress of merchant or lawyer of the time of Louis Philippe. His pose and mien is that of one of Ingres's distinguished bourgeois clients waiting to be drawn by the artist.

During these years, he met an actress, Valentine Delafosse, who became his mistress and lived with him, helping him print his photographs until she died in 1926, a year before his own death. As the jobs in the theater gradually disappeared, Atget reached a crisis in the direction of his work and career. At first he thought of turning to painting, a field that had long fascinated him, but it was too late to develop whatever talent he might have had. A few neat sketches that have survived reveal no latent genius in that direction.

Having moved to Montparnasse, where he had met a number of artists—Vlaminck, Utrillo, Braque, and later his neighbor, Man Ray—he made the decision to take up photography and to supply prints to artists looking for subject matter for paintings. It was an old and honorable trade extending back to the seventeenth century when artists/draftsmen like Daniel Morot made it their business to supply patterns to painters, architects, sculptors, and gardeners with "pensées," as Morot called his little engravings. He had frequented the artists' studios and had developed a sense of the kind of thing they might respond to. The use of photographs by painters as "sketches" was as old as photography. Artists actually took up photography in order to assemble their sketches. As early as 1855, an urban genre scene by Charles Nègre was copied directly from a calotype photograph. It was an old-fashioned technique by the time Atget began to try to market his photographs. Already, the younger painters were reacting against such mechanical methods of composition. Along with his interest in the theater and in painting, he had developed a peculiar interest in the appearance of things as history, of buildings, of places, and, above all, of views of his adopted city of Paris. The city's traditions, its accumulation of experience, were a mass of secret fingerprints, the evidence, hidden in its cobblestones, quays, the wallpaper of its brothels, and, of course, in its overpowering monuments including the parks with their profusion of statuary, fountains, basins, trees, and graveled walks. It is on this evidence of history that Atget the crime photographer was to perfect his craft in order to make his living in that calling for the rest of his life. He had also chosen a body of evidence that even in ten thousand separate images he could not exhaust. His friend Victorien Sardou, the well-known playwright he had met in the theater, apparently shared Atget's passion for the same Paris that enthralled the novice photographer. It was Sardou who first encouraged and apparently guided Atget to historic buildings and districts just a step ahead of the demolition crews moving through the city feverishly working to destroy and to transform it. "Victorien Sardou told him which houses, which sites and châteaux, which spots were doomed," Calmette recalled to Berenice Abbott. It was during these same years that the Musée Carnavalet was created to preserve

fragments of the city's history and where Atget's documents would become an important part of its collections. As an instinctive urban historian, Atget worked to master his subject and to perfect a large, clear image made with a contact print from the glass negative. At this level, Atget's photographs became a unique primary source of history with no retouching or studio cosmetics. The painterly photograph celebrating the cult of art or the ritual portrait, both fashionable, even dominant at the time, did not interest him.

Photography as art attempted not only to reproduce the texture, light, shade, and aura of paintings but also to give the finished product the unique existence as a work of art in time and space. Some photographers actually destroyed their negative plates after a limited number of copies were printed, attempting to perpetuate the Renaissance cult of the unique "authentic" work of art. The Renaissance cult of beauty and its celebration of the artist's creative achievement also entered into the photographic process through this effort to defy one of photography's essential qualitites, that of mechanical reproduction in unlimited quantities.

Some of the more sophisticated practitioners were naturally challenged to wipe out the differences between photographs and engravings or drawings through the manipulation of the reproduction process itself. Artists like Corot had experimented with the possibilities of converting the negative plate into a new method of reproduction by drawing on its surface. Often the results were so successful that it is difficult to separate one medium from the other when we see them reproduced in books of the period. In 1899, Robert la Sizeranne's book, *La Photographie est-elle un art?*, reproduced photographs so close to lithographs and etchings that they were almost indistinguishable. Some had plate-marks; one subject was presented in separate states. By the end of the century, different kinds of photographic surfaces had been developed to simulate oil paintings, pastels and drawings on paper. In some cases, the texture could be built up by successive layers through the use of gum-bichromate emulsions.

The portrait, which had been the focal point of early photography, also continued to preoccupy the professional photographer at the time Atget was entering the field. The human face, as Walter Benjamin points out in his brilliant essay on the medium,* gave the photograph "a cult value" as a unique image recording the fleeting expressions of loved ones, absent or dead. The stark and riveting faces of some of the earliest French primitive portraits of the nineteenth century capture this ritual quality, investing them with "their incomparable sad beauty." With the development of new materials capable of investing portrait photography with the hand-touched quality of a painting or a watercolor, portraiture employed more and more artistic techniques of dubious fashion.

But neither photographic portraiture nor the challenge to duplicate painterly problems seemed to appeal to Atget. In many ways, in both attitude and instinct, Atget was closer to the clarity of vision and the poetic enchantment with the commonplace scenes and objects of the early primitives. Many of the early French photographers had also been painters or in some way connected with the artistic community in Paris, a common link that Atget also shared. For the most part, they were failed painters without much reputation, and their somewhat displaced, ambiguous Bohemian existence was a world that Atget was later to be a part of.

Like the primitives, Atget's images reflect a kind of innocent amazement at the medium's power to record details in the infinite combinations of shadow and light. But unlike the primitives, who concentrated chiefly on the results, Aget continued to study and experiment with the medium itself, forcing the camera, lens, printing process, and paper to impart those qualities he thought

* Walter Benjamin, "The Work of Art in the Age of Mechanical Reproduction," *Illumination* (New York, 1955).

important. During the fifty years that separate the early primitive period of photography and Atget's first work, the ubiquity of the photograph, its widespread commercialization, the advancement of techniques, and a shift in aesthetic criteria had all but eliminated the intuitive simplicity of the earlier photographers. Yet, for all of the calm, detached naturalism of Atget's work reflecting this evolution, his unequivocal images, straight and seemingly without style, recall the memories of the earliest history of the medium in his unparalleled ability to show us things and to be challenged by them.

In the deserted streets of Atget's Paris, which Hilaire Belloc found "noisy with an infinite past," he shows us the dead rabbit hanging in the butcher's shop, the worn step, the broken statue in the park, or the twisted tree. His photographs have created a new language, already freighted with class and caste that is inexplicably French. In them there is more than a hint of history's violence, though largely unintelligible to outsiders without the translation through his camera's lens. But, as Walter Benjamin proposed in his essay on Proust, "Is it not the quintessence of experience to find out how very difficult it is to learn many things which apparently could be told in a very few words?"

In some rather melodramatic passages in a short biographical note, Jean Leroy has given us a picture of Atget at the time that he took up his new career as being ashamed of his vocation after failing at acting and painting. "He always felt a sense of inferiority in the presence of his artist clients, which embittered him," Leroy writes. "He never really accepted the life which was his lot, and, despite his reticence, one felt that his whole being revolted against it, though he worked with courage, but always with the feeling of a deep deception at the bottom of his heart." What nonsense! And, as Abbott has amply refuted, quite aside from the monument of his work itself, his obsession with mastering the techniques appropriate to his purposes, his tireless experiments both in the city and in the outlying gardens where he would work long hours or even months and years in order to understand different qualities of light and shade during the day and the changing moods between seasons, deny Leroy's unfounded apologies. When Atget began to sell a few prints to friends and artists, he realized he had discovered his calling. "He sold his documents," Calmette wrote, "proud and happy, he made a living from his work for himself and his companion."

Of course, he was not a success as measured by the most modest aspirants to that label in Paris in 1900. Nor for that matter was he a starving misfit as has often been implied. His Bohemian years in the theater had taught him how to survive while he did what he had to do, what he wanted to do. He refused to take pictures on conventional assignment because "people did not know what to photograph," although he did work with the libraries and official photographic depositories. There was a tradition in France to document the architecture and historical scenes of the nation. As early as 1851, the Commission des Monuments Historiques had authorized photographers like Henri Secq, Gustave Le Gray, and Hippolyte Bayard to carry out this work. In the same decade the government began to purchase whole photographic collections as well. Atget's later work was a continuation of this patronage.

As late as 1925, Delarue-Nouvellière, who knew Atget, said that he was selling his 18-by-24 prints for no more than five francs apiece. When Abbott first met him through an introduction by Man Ray, even as a struggling artist herself she was struck by his apparent poverty—the old clothes, the bare studio-quarters, his tired, remote air. Still, his clients—the painters, sculptors, illustrators, amateurs of old Paris, sign painters, and librarians—bought enough from him so that he was able to pay for his supplies and could survive with his devoted mistress in his apartment, which served also as a studio.

Atget's apartment on the fifth floor of the house in the rue Campagne Première was Spartan. The dining room served as a darkroom, and the prints were washed in the kitchen. A photograph of his studio shows a work bench made from old crating, simple shelving on the walls, and a pine desk with the tools of the artist, including an old-fashioned straight razor apparently used for cutting paper, though he never trimmed his prints. The edges of his compositions are important and can be distorted by modern exhibition matting or book reproduction where this critical area is removed for purposes of layout. His intransigent French spirit showed in everything he did—Calmette called it his "intransigence of taste and processes"—the uncompromising work habits, his austere quarters, even his diet, which consisted of milk, bread, and a few lumps of sugar. In a strange way, his singular approach to his art, his rigid, if unconventional, work habits, and his hypochondria had about them something of Proust's unconscious, radical self-absorption in his cork-lined room.

Atget's reticence, his remoteness—an unwillingness to communicate amounting almost to an impenetrable mystification—was remarked upon by everyone who met him. Perhaps like Walter Benjamin, he too thought of himself, in temperament at least, as a melancholic.* Like Benjamin and other artists of the period from Proust and Kafka to Paul Klee, who were "essentially solitary," Atget's temperament allowed him to maintain his solitude in a busy urban setting and to resist its distractions. It may well have had something to do with his selection of subject matter. Something akin to that condition of Proust's "loneliness which pulls the world down into its vortex," in Benjamin's words, could also explain Atget's attraction for empty gardens and the limbo world of the suburbs as photographic material, where he was to return again and again to create his own *jardin imaginaire.* His silence was a disguise that masked an audacious, passionate, self-aware artist, appraising, selecting, pondering, recording the doorways, arcades, street vistas, and public spaces of Paris. "True art," as Proust observed on an artist's privilege of letting his work speak for itself, "has no use for so many proclamations and is produced in silence."

But without proclamations from either a mute artist or an indifferent public, Atget seemed to find the creative act in attempting to decipher a complex environment and its secret language sufficient inspiration, since acclaim and money figured little in his life. Coming late after detours and delays to a field that now completely absorbed his imagination, his preoccupation with his work ruled out any time to promote his own talent. When the doorways of an entire street, a row of store fronts, a series of seventeenth-century iron stair rails, caught his eye, he would photograph them one after another without stopping to regard the results as salable works, and they rarely were. It was not unusual for him to return to record a favorite scene or a special tree many times, separated by long intervals. In one case of an urn, there had been sufficient time between his visits for the graffiti to be washed off by civic caretakers. These moving-picture sequences of Atget's can have an almost musical quality to them in their "freeze-frame" cadence, but they were lost on the fashionable, pictorial tastes of *la belle époque.*

After he had completed a group of photographs, he would then take them around to his prospective clients, many of whom were artists living near him in the same quarter. Some of the artists admitted later that they bought his prints more out of charity than any real appreciation. A few of the artist friends did, in fact, use his photographs as source material for their paintings. Man Ray, Dunoyer de Segonzac, and Derain used Atget photographs as reference. Others, like Duchamp, Vlaminck, Utrillo, Braque, and Picasso, were at least familiar with his work.

* I am indebted to Susan Sontag's essay "The Last Intellectual," *New York Review of Books,* October 12, 1978, for suggesting the line I have taken connecting Atget's personality with an old tradition of melancholia.

While the photographs of street scenes, the quays, the picturesque courtyards, confirmed the kind of images familiar to these artists, the more surreal quality of Atget's works in the gardens of Versailles or the Tuileries does not seem to fall into any thematic category of his clients' tastes and images. Nor do the gardens seem to fit into the large, vague projects that Atget carried out, documenting architecture, historical buildings, and monuments around the city for his potential library customers. The parks and gardens, as some private theme we have not yet unraveled, seemed to have their own compelling attraction for Atget that placed them as subject matter outside of his usual bread-and-butter material. In the early 1920s he asked permission to photograph the interior of a number of important churches around Paris, and it may be that he intended to create a series of photographs on parks as well as churches, like his other unrealized plans to create collections he called "L'Art Décoratif dans les environs de Paris" and "L'Art Décoratif dans le Vieux Paris."

Just what inner meaning and irresistible appeal the seventeenth-century parks—those utterly sophisticated landscapes where the face of nature seems molded by man's passions and visions—had for Atget is hard to determine beyond the statement of the photographs themselves. They may have represented to Atget what the American landscape had held for Walt Whitman when he referred to "the large, *unconscious* scenery of my native land." There is something in the ordered geometry, the historic memories, the Cartesian grid of a French formal garden with its supernatural space, that is irreducibly and peculiarly "native." The harmony of its composition subdued by time, its fine quality of age and aloofness hiding old crimes, intrigues, assignations, and revolutions in a wilderness of intersecting walks, makes up a kind of national *mise en scène* the way that the Rocky Mountains supplied a "native" image for American artists and photographers in the nineteenth century. This is not to suggest that gardens were a "popular" French subject, like the American West was to American artists when Atget took up photography. There were the usual anonymous tourist views and the ubiquitous postcard of Versailles, of course, but beyond that, few serious artists or photographers were attracted to the subject. It was a theme that Atget seemed to have invented for himself, though the image of the garden in numberless cheap engravings from the seventeenth and eighteenth centuries could be bought in any sidewalk print shop. In that sense and, above all, in the overwhelming presence of these great public spaces themselves in and around Paris, they were an "unconscious," though powerful, native image of landscape scenery.

At the end of Louis XIV's long reign, the manicured gardens, centered at Versailles—which he had made the symbol of his empire—were becoming shabby and overgrown. For, as a symbol of an unfashionable era and style, the tyranny of those gardens did not appeal to the more permissive Regency that followed the Sun King. In many respects, the gardens' appearance in the 1720s, after the King's death, must have approximated the unkempt air that Atget recorded at Sceaux in the early twentieth century, another period of transition. The romantic impression of choked avenues, peeling paint on balustrades, and broken statuary we see in the photographs remind us of scenes we have known before. Suddenly we recognize in them the garden settings for Watteau's picnics, Fragonard's fêtes, Moreau's nightmare *bosquets,* and Oudry's lonely garden stairs leading nowhere—the work of eighteenth-century artists who had been attracted to the same battlefield where Atget's camera would also record the continuing war between art and nature. For the eighteenth-century romantics, it was exhilarating to see nature getting the upper hand by suddenly filling in the clipped spaces and occasionally toppling the statues and urns. But where Watteau and Fragonard could build up the mysteries of nature with pigment, Atget's probing search of the deepest background through the long exposures and tiny aperture focuses on a totally different perception of light and shade, of texture and mood, yet of the same romantic material. Still, the memory of these earlier artists, their

compositions, their fascination with the relationship between sculpture and nature, seem to lurk in the shadows of Atget's images. Like Atget, Watteau had also been attracted to the theater, where he worked on sets, and many of his garden landscapes have an undeniably theatrical backdrop quality, a quality we also sense in many of Atget's garden photographs. Perhaps the garden as an attempt to re-create an image of idealized nature has a special attraction for theatrical types who constantly search for an ideal replica of the real world.

Certainly the French have had more than their share of artists, architects, and gardening talent willing to reorder nature in the name of an ideal. And French artists like Silvestre, Watteau, Fragonard, and Hubert Robert have produced some of the best pictures of that garden ideal. To this tradition we must add Eugène Atget's name. His marvelous private poem composed of trees, earth, marble, water, and sky, like those basic elements of the classic garden itself, grows out of a rich past suddenly illuminated by the clarity of his unique vision. It was, in Berenice Abbott's words, a vision perfected by "punctilio . . . and infinite pains."

The Gardens

Versailles

The sun's bright palace on high columns raised with burnished gold and flaming jewels blazed.
Ovid, *Metamorphosis, Book II* (trans. Joseph Addison)

If it were only a ruin, then perhaps we could deal with its colossal size, and like Diocletian's palace or the Villa Adriana, ignore three fourths of its sprawl for a few crumbling details or remote corners to savor. In a way, this is what Atget was able to do with his camera at Versailles and in the other parks. Dragging with him the awkward, heavy equipment, the tripod, the outdated long-barreled lens, which would sometimes cut off the upper part of his print and turn the corners dark, he must have seemed like a sinister figure on the edge of a dream as he quietly studied the place from every angle. The long, damp avenues melting away into the gray walls of treetops, the recesses of the narrowing walks, the triumphant urns, the "redundancy of more or less chiseled marble . . . a forest of statues as well as trees," Henry James exclaimed; the immense domain was ripe with intimations of history.

But as a place that attracted successive generations of major artists or even competent topographical recorders to celebrate its awesome spectacle, Versailles has somehow lacked that kind of appeal. The lavishness and the arrogance of its dimensions, the grand, overwhelming effrontery to nature, seem to have discouraged most artists, especially when the place was new and shining, with too much detail and color. Even the lead figures and flowers in the fountains were painted. The weight of the despotism was overpowering. The heavy footprints of the King, who enjoyed riding roughshod over nature and subduing it, are still too obvious. "Beauty and ugliness, spaciousness and

meanness were roughly tacked together," Saint-Simon complained. The pavilions, the *bosquets,* the endless perspectives, the suffocating repetition of the Apollo motif amounting to a plague, play into the hand of Cotelle's mythologizing incompetence that we see in the series of garden views now hanging in the Trianon. Even though his touch was light, the whole affair looks even more fake than in fact it was with the introduction of the complaisant mistresses turned goddesses draped around the pools and canals. Like the meaningless deities at the end of the Roman Empire, the gods and goddesses surrounding the Sun King were now only a part of the theater, with minor roles to play.

If one were to name those few artists over the centuries who have attempted to capture that inexpressibly moving quality of the enigmatic spaces and poignant details of a French garden—the theatricalism of Vaux-le-Vicomte when it was new or the mature, romantic, overgrown walks of the Tuileries and the Luxembourg in the eighteenth century, for example—the list would be very small: Israel Silvestre and Jean Lepautre in the seventeenth century; Antoine Watteau and Honoré Fragonard in the first half of the eighteenth century, Hubert Robert at the end; and Eugène Atget.

Israel Silvestre's drawings and engravings of landscapes and topographical views are among the most sensitive works of their kind in the seventeenth century. Perhaps it was because they were newly laid out, but his drawings of the gardens of Vaux and of the Tuileries prepared for the engraving have a morning freshness to them that one can fairly breathe: the masses of new foliage on either side of the avenue, the clipped and squared parterres, the beds of flowers newly set out, the central axis running majestically to the horizon. It was still a moment when the whole thing could be taken in and reduced to a piece of paper not much larger than Atget's negative plate. Silvestre was the "photographer" for the court and the nobility, recording the châteaux, fêtes, gardens, and countryside of that Golden Age. His views encompassed all there was to see, or so it appears, and if this was the garden as at Vaux, that meant that his wide-angle focus included not only the green palisade walls that framed the vast layout but the far horizon as well and everything in between. More than seventy-five figures can be counted along Vaux's half-empty walks and terraces. Molière, Fontaine, Lully—all of the artists of Fouquet's newly acquired Parnassus—may well be among that elegant society assembled by Silvestre and seen loitering in the grounds. It is the memory of that Elysian company briefly enthralled by their patron Fouquet and briefly writing plays and poetry and composing music for his short fame that gives Vaux its poignancy. It is history's missing "hum of implication" that was once there, as Lionel Trilling noted, which creates, in places like Vaux and Versailles, the melancholy void we can suddenly encounter without warning. The commissions for Silvestre's documents, however, were not intended to penetrate the microcosm of Atget's private garden world made of the seductive details of a statue or an urn, long mysterious avenues, or a stone frog sitting on the edge of a cascade from which we strain to guess what the sounds of those "implications" were.

The central perspective of the main avenue of a French garden leading from the château to infinity on the horizon is, of course, the spinal cord of its composition. The immediate origins were Italian, worked out in the geometry of the architecture of the early Renaissance, but its history stretched back to Vitruvius and classical times. Alberti, Vignola, and Serlio left no doubts that symmetry, order, and proportion were the only rules to follow if one's house and its surroundings were to be morally and aesthetically acceptable. In the sixteenth century Vignola and Serlio were in the vanguard of the Italian invasion of artists, architects, sculptors, garden designers, and theatrical impresarios who were drawn to the court at Fontainebleau and Amboise, where everything from gardens to manners were Italian-inspired.

By the time Le Nôtre had remodeled the old Tuileries gardens in the 1660s, extending its

avenue from the center of Catherine de Medici's palace over the flat plain to the west and then up the long hill to the Étoile where the avenue Champs-Elysées now runs, the main axis had already become something of a cliché in French garden design, growing longer and wider according to the builder's ambitions and wealth. Le Nôtre, however, had the genius or the political judgment to reserve the grandest projection of a garden avenue for Versailles itself. If you measure it from the approach through the town to the horizon opposite the palace, it is over eight-and-a-half miles in length. Le Nôtre's success was in knowing how to handle such enormous space and to manage its proportions and scale in keeping with the imperial visions of Louis XIV. Later in the eighteenth century those garden avenues would become the model for whole cities carved out of the wilderness.

So in Atget's intense concentration down the Allée Royal at Versailles or in similar avenues now shabby and overgrown as at Sceaux or St.-Cloud, there is not only the receding perspective of the walk itself but a "document" of history running from the Rome of Vitruvius and his architectural theories through the early Italian Renaissance and on into the great gardens of sixteenth- and seventeenth-century France. It even extends beyond into the radiating avenues of L'Enfant's grand design for the new federal city at Washington.

By the time Louis XIV had died in 1715, the immediate gardens of Versailles constituted over 230 acres, roughly the same area that had enclosed the old hunting lodge belonging to Louis's father. But the Petit Parc just beyond now covered 4,000 acres and included the Lac des Suisses, the Grand Canal, and the Trianon. The Grand Parc, reserved for the royal hunts, embraced nearly 15,000 acres and was enclosed with a wall over twenty-six miles long.

Even though the Grand Parc was squandered in development and subdivision at the Revolution, the rest, or at least its outline, was still intact at the time Atget knew it. And while other royal domains were destroyed, divided up into lots, or greatly reduced in the early decades of the nineteenth century, still much of the former royal establishment continues to provide enormous pastoral spaces in the environs of Paris. It is a heritage of real estate—a "visitable past," Henry James called it—that extends back to the beginning of the modern state itself.

The idea of the garden as a noble retreat for the prince, where he could escape the cares of state and the heavy duties imposed by a complex court society, has appeared in many cultures throughout history. The classical writings of Pliny, describing the country solitude of a Roman gentleman of affairs resting in his garden rooms or walking along the covered alleys by the pools, canals, and fountains, had stimulated the imagination of the Renaissance. In their descriptions of the pleasures of a garden existence, early Renaissance writers like Pierre Cresent and Giovanni Pontano gave special attention in widely circulated books to the prince's garden and its function.

Pleasure, peace, and spiritual refreshment distinguished the nobleman's park from the merely utilitarian gardens of vegetables, herbs, and fruit trees. Within the harmony of its design, its sensual pleasures of sights, smells, and sounds, exotic flowers and trees, fish ponds, aviaries, and menageries, it was a kind of earthly paradise that might have suited a king of Persia, where, in fact, the word "paradise" itself had originated. Even before the Renaissance had discovered the classical writers of antiquity singing of garden retreats, of ease and love in the shade, the French had already shown a special sensitivity to landscape and to the pleasures of the garden life. It was in a French garden that modern love first appeared or was at least given its literary form in the great allegorical tale of the twelfth century *Roman de la Rose.* In the verses of the *Roman,* courtship was pursued in the garden with an elaborate protocol of ritual, music, poetry, and manly trials replacing the animal rudeness that had prevailed for centuries.

By the time of the French invasions of Italy at the beginning of the sixteenth century, the art

of landscaping on a grand scale was already well advanced in Florence, Rome, and Naples. The gardens and pavilions of Alfonso II in Naples were the forerunners of the pleasure houses that were to be built over the next three centuries in and around the Île de France. The sheer luxury and beauty of Alfonso's Poggio Réale, built purely for pleasure, so astonished the French King that he lost no time in recruiting Italian gardeners, architects, hydraulic engineers, and anyone else with skills in the paradise line to return with him to France. It was only the first of many Italian invasions of artists that continued into the reign of Louis XIV when Bernini was invited to Paris to redesign the Louvre.

By the beginning of the seventeenth century, peace and stability—ingredients as essential to great gardens as sunshine and water—had allowed the French kings to move well beyond their old moated castles into the countryside. A new prosperity encouraged villa building by the nobility on an unprecedented scale. Those who prospered the most were the officials like Richelieu, Mazarin, and, later, Nicolas Fouquet, men in strategic positions to appropriate public funds for their private extravagance.

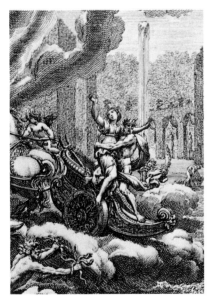

Persephone and Pluto

In all of this, the symbol of the château and especially the garden on a new and superhuman scale became the measure of the builder's power itself. Thirty years before Louis XIV staged his first royal fête at Versailles, Richelieu was building a country palace and garden, with a new city of astonishing proportions and extravagance attached to it. The Château de Richelieu anticipated in grandeur the later development of Versailles. Even La Grande Mademoiselle, the richest woman in the realm, was impressed though not surprised, "since it was," she remarked, "the work of the most ambitious and ostentatious man in the world."

The flat, yielding topography of France allowed the aristocracy, aided by ready, willing, and supremely capable garden designers like the Mollets* and the Le Nôtres, to let status and composition have much freer rein than in Italy. Their astonishing imaginations could readily encompass literally thousands of acres within their ordered vision. The Italian gardens, on the other hand, were usually on steep, difficult sites which had restricted their size to a more human scale. The uncertainties of political fortune, a peculiar French impatience with nature's normally slow ways, and the concept of the garden as a temporary theater set or stage had accelerated the speed with which great seventeenth-century French gardens were created. The consequent cost did indeed require a national treasury, and the results were measured in terms of the national debt.

Vaux-le-Vicomte—celebrated in French garden mythology more for having brought its builder Nicolas Fouquet to sudden and dramatic ruin than for the fact that it is Le Nôtre's masterpiece—was built in five years. The tragic revels leading to Fouquet's disgrace, arrest, and imprisonment were staged in August of 1661. Molière wrote the play and staged the ballets for the celebration. Lully composed the music. Italian set designers worked their fantasies with theatrical tricks, fireworks, and illuminations of every kind. By December, however, following Fouquet's arrest on the King's order, the orange trees and sculpture were being removed from Vaux and were beginning to arrive at Versailles. The King knew exactly where the money had come from, so it wasn't an act of vengeance to appropriate the trees and Poussin's garden termes. The young Louis had made up his mind to run the show, to create the premier garden of France—ultimately of Europe—and was not to be upstaged by a mere Minister of Finance. Somehow it recalls to mind the Assyrian hieroglyphic fragment in which a victorious king "carried off from the countries I

* Although not as well known as the Le Nôtres, the Mollet family contributed to the theory and practice of garden art through several generations, beginning in the sixteenth century with Jacques Mollet, who was chief gardener at Anet, Diane de Poitier's château.

conquered, trees that none of the kings, my forefathers have possessed, these trees I have taken, and planted them in my own country, in the parks of Assyria have I planted them."

In building, as in everything else, Louis was quite different from his father, who, as one of his courtiers noted, was "not given to building," in marked contrast with everyone else at the court at the time. Versailles was originally built as a hunting lodge by Louis XIII, and it was so unimpressive that the Duc de Saint-Simon called it, "a little pasteboard château," which the King had built to avoid sleeping on straw. The site, first of all, was impossible. Saint-Simon thought it was, "of all places, the saddest and most barren, with no view, no water and no wood, for it is all shifting sand and marsh."

Even now when one wanders beyond the palace and the symbols of statecraft at Versailles, there is still a certain indigenous quality of sadness in the terrain, heightened by neglect, which is the mood in many of Atget's plates. In a way, Atget understood the theatrical possibilities of melancholy almost better than any other photographer. We see it in the overturned chair under the trees, the pale light falling over the worn, empty steps and running down the water-stained face of Coysevox's *Nymph with a Shell.* The hallucinatory atmosphere of some of his rows of trees stripped bare by winter can be heartbreaking. Yet they are just ordinary park chestnut or beech in December or January making a special appeal for our pity out of season. Henry James thought it was the perfect time to visit French gardens: ". . . all deserted palaces and gardens should be seen in the chill and lifeless season. Then nature seems to give them up to your sympathy and they appear to take you into their confidence." It was a mood that appealed to Atget as well.

With little in nature to recommend it, it is hard to see why Versailles's location was selected or perpetuated. For Louis's father it was just a good hunting park. For Louis its original appeal may have been nothing more than an escape from the memories of the humiliations he had suffered at the hands of the Fronde as a child in nearby Paris. After Fouquet's disgrace, his artists as well as his orange trees were appropriated by the young King. When Le Nôtre, Le Vau, and Le Brun came to work at Versailles, they became Vaux's real legacy. At first, it was only decoration, cosmetics, impressive gilding on the outside for a temporary playground. The first gardens were mainly a consolidation of the earlier parterres of the old hunting lodge.

With Mazarin dead and Fouquet locked up, the early years of Versailles are linked to the King's growing power and his love affairs. The remote lodge was well removed from the stuffy atmosphere of St.-Germain-en-Laye, and Le Nôtre's new gardens, "opening in accordance with some preordained symmetry into vast amphitheaters," was the perfect setting for sumptuous spectacles. Fireworks, ballets, plays, elaborate promenades by the entire court, became a part of the garden ritual costing millions. Still, Colbert found it a cheap way to divert the King from the costlier temptations and glamour of war.

At first no thought was given to housing the entire court at Versailles when it was invited for a visit or when one of the great fêtes was staged. The inconvenience caused endless complaint by the guests. "The courtiers were in a fury because the king did not take care of them," Oliver d'Ormesson recalled in his memoirs. "M. M. de Guise and d'Elbeuf had scarcely a hole to shelter in."

It was not until 1668 that Le Vau's plans known as the "Enveloppe" were approved and the new additions wrapped around three sides of the old palace. No longer just a royal amusement park, the architects, gardeners, sculptors, and water engineers were now set on transforming Versailles into the seat of a mighty government. The gardens were an essential element in the political scheme.

The tranquillity of those flat, still sheets of water in the basins of Versailles to which Atget's

camera was drawn does not reflect their costly history. For water, in ever-increasing amounts, like a Los Angeles or Arizona desert irrigation project, was an obsession at Versailles. It drained fortunes, took lives, and destroyed engineering reputations. Despite the great and costly reservoirs, the fountains continued to dry up.

"Bright streams of water must run through the garden," Alberti had written in *De Architectura,* "and above all must start up unexpectedly, the source a grotto." What a simple, classical solution! But no magic spring appeared in all that swampy ground that could feed the 114 fountains and water pieces of Versailles and Marly with bright and endless streams. It was as someone said, a *cité d'eau,* and the superhuman effort it took to achieve the stunning effects was a part of Versailles's mystique, its politics—like the Valois fêtes the shrewd Catherine de Medici had staged the century before to impress foreigners as a part of her Italian statecraft. Using water for luxurious garden diversion was part of the royal game to be played. In unimaginable quantities it communicated incredible power and luxury.

As the dimensions of Le Nôtre's landscape plans outran both the architecture and the water system, Colbert accused him of forcing the King's hand into accepting further expansions of the château. At first the water was raised by a humiliating one-horse pump from the lake at Clagny. The system was so inefficient that certain fountains could be turned on only when the King was in that part of the garden. Even when he was on military campaigns, the King, still thinking about his garden, would fire off letters to Colbert. "You must arrange for the pumps at Versailles to work properly," he wrote, "so that when I come back I will find them in a condition that will not exasperate me by their breaking down."

But in the gardens Le Nôtre was building, with their vast, numbing formality, water was essential for other reasons and the King knew it. Its movement and reflection, now bright and rushing, now tranquil and formal, were a necessary ingredient in all that staggering space, to give movement and scale. The Academy of Science was brought in; the generals were given orders. Vauban, the military architect, was consulted and then dismissed. At one point, there was even talk of abandoning Versailles altogether "and build in a more happy situation." One mad plan involved nothing less than the diversion of the river Loire itself to Versailles until it was discovered that the river was well below the elevations of the palace gardens.

The greatest disaster was an attempt to build an aqueduct thirty-four kilometers long, stretching through the forest of Rambouillet, to bring the water from the Eure River, but the loss of life was so great that it could not even be discussed, according to Saint-Simon, "under the severest penalities . . . ; who could count the gold and men lost!" Finally, in 1684, the *machine de Marly,* with its fourteen gigantic waterwheels and 221 pumps, lifted water from the Seine to reservoirs 162 meters above the river.

All this for a garden. But there were other considerations that underlined the primacy of water at Versailles. From the first large-scale fête staged in 1664 by Molière as an entertainment for the King's new mistress, Louise de la Vallière, court spectacles played an important function at Versailles. Their very magnitude required that they be presented in the gardens, and water became the backdrop for many of these pageants and pantomimes. In the *Plaisirs de l'Île Enchantée,* as we see in Silvestre's engraving, Alcine's palace was carried across the waters of the Bassin de Cygnes by a great sea monster accompanied by nymphs. Finally, with a clap of thunder and a flash of lightning, the whole palace burst into flames and a magnificent display of fireworks ended the three-day entertainment as the enchantress' castle sank below the water.

The combination and contrast of water and fire are always compelling, and the King's

fireworks at the end of the fête seemed to set sky, earth, and water aflame. The great height of the rockets and those that suddenly rose back out of the water as if by magic after having gone down were indeed a great enchantment. The manipulation of the elements on an unprecedented scale was one of the tricks of a supreme monarch.

The King that one sees at the end of his reign through all the wreckage and personal sadness of his old age was not enhanced by the heliocentric system of decoration Louis had adopted in his youth. The handsome, forever young Apollo and all his family, the golden promise of the Sun emblazoned everywhere and on everything, only dramatized the decay. "It must first be pointed out," Félibian wrote in his guide to Versailles, "that, since the Sun is the emblem of the King and since the poets confound the Sun and Apollo, there is nothing in the superb residence that is not related to this divinity." But it was not to Apollo's heaven that the old King now directed his attention when, in 1710, the new chapel (Saint-Simon with his usual spleen called it a "horrible excrescence") was finished. For the next five years, until his death, Louis spent more time there than in the gardens.

Probably the most striking thing about the palace and grounds of Versailles during the closing years was that now only the seasons changed. Everything else, as far as Louis was concerned, had been completed. The armies of workmen, the scaffolding, the piles of stone, the huge trees being moved, the incredible atmosphere of a royal Barnum & Bailey Circus being perpetually put up and taken down, had quite vanished into the mist that one still sees in some of Atget's pictures. The silence of those last years anticipates that gnawing silence that seems to lick at the naked branches of Atget's trees. *"Tout est mort ici,"* sighed Madame de Maintenon near the end, *"la vie en est otée."*

The palace with its insistent memories stood empty and shuttered for nearly a decade after the King's death. The Duc d'Orléans, the Regent, hated Versailles and turned it into a guest house for foreign princes—usually German. "A young man passed for an imbecile if he had not stayed for some time at Versailles," Frederick II wrote. And Peter the Great was put up first in the Queen's apartment and later in that of Madame de Maintenon at Trianon before he departed with a French gardener and visions for the Peterhof, a Versailles on the Neva. In the summer the public was free to roam in the gardens until the autumn chill and leaf-choked walks with their naked trees and even more naked gods and goddesses drove them out of the brooding place.

When the court finally returned to Versailles in 1722, a place Louis XV also disliked, it was ominous that the fireworks display scheduled to celebrate the occasion was abruptly called off, "not judging it convenient," the Regent said. No doubt it was the Regent's depression at having to give up his orgies and debaucheries at the Palais Royal to live in the gloomy province of Versailles that had caused the cancellation. Nor were the great fêtes often revived during the remainder of the century.

The Revolution did little damage to the palace or gardens beyond emptying out its contents. The report of the commissioners of the Service des Batiments in 1791 describing the rifled, unfurnished rooms of the château attests to the thoroughness of the dispersal sales after the King's execution. Only a few books and some sheets of music had been overlooked in the library. When the monarchy finally fell a year later, things took an ugly turn and a wagonload of aristocrats, including Du Barry's friend, the Duc de Brissac, was set upon by the mob near the gates of the Orangerie and dispatched, but the grounds or buildings themselves were not touched.

Napoleon moved into Pompadour's apartment in the Grand Trianon and proposed that the nymphs and fountains of Versailles be replaced by "panoramas of masonry and models of conquered towns," though just what kind of neoclassical extravaganza he had in mind is not clear, for the call

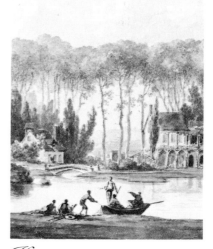

Hameau

to further conquests intervened as far as the gardens were concerned.

When Louis Philippe later moved into the Trianon in the 1830s (the palace by now had become an indifferent picture gallery "and a resort of patronism and the arts"), he filled in Mansart's colonnade with windows and, with a nice Philistine touch, added exterior shutters that gave the place the bedraggled, sad air of a seedy nineteenth-century spa one sees in some of Atget's views.

International money, national pride, and the profitable return from tourists have spurred restoration and removed all of Louis Philippe's shutters. Ruthless scientific renovation proceeds to polish up the past of the principal structures. Marie Antoinette's childish whimsies of the well-maintained *hameau* are not at all the same buildings we see in the illusion that Atget's photograph conveys across the English lake. Yet late in the fall, walking in the deep shadows through the tall grass of the park toward the Trianon with one's collar turned up like Proust's against the demoralizing air and with only a few people in the distance who seem to disappear upon approach—like the celebrated phantoms encountered by the two English schoolteachers—we find that it is as much Atget's world we have entered as it is the sweet graveyard of the Sun King's dream.

St.-Cloud

The animated extravagance of its setting is now threatened on all sides by suburbia and commercialism. From the top of the hill looking over the cascade and traffic of the Périphérique, the gray-green trees of Louis Napoleon's Bois de Boulogne still look fairly dense and protective across the river where the worst of the high-rise developments shoot up above the tree line. Perhaps it was the nightmare vision of these and numberless other excrescences that drove Atget on in order to salvage his documents of history. The spread of the city in all directions beyond its old boundaries had actually started with the enterprise and opulence of the Second Empire. Streets, boulevards, and bridges pierced the old suburbs around St.-Cloud. Swiss chalets, Norman châteaux, Italian villas, and *maisonettes à la Moyen Age* stretched over the hills south and west of the city. It was, it seemed, and long before the high-rise towers of the multinationals, the dream of every little shopkeeper who had saved money to disfigure the landscape around Paris.

Even before Atget explored the gardens of St.-Cloud with his camera, the vandalism of Napoleon III's disastrous war of 1870 had actually destroyed the château, the centerpiece of the vast park above the river, leaving, however, Lepautre's cascade and about a thousand acres around it. It was especially the cascade that had always attracted visitors, especially on the days when the water was turned on. "They play," as the old guidebooks used to say, "on alternate Sundays during the summer months from four to five o'clock."

That intrepid English visitor to Paris in the 1690s, Dr. Martin Lister, spent almost as much time at St.-Cloud as at Versailles admiring its beauty. "From the balustrade in the upper garden, the river Seine and a vast plain bounded by Paris is to be seen and makes a most delightful prospect," Lister noted in his diary. He watched the cascade "play" several times and was even more impressed by a *jet d'eau* "that threw a spout of water ninety feet high . . . and gave now and then cracks like the going off of a pistol. . . ."

There is nothing subtle about St.-Cloud, and even now it seems at home in its vulgar suburban neighborhood. So much of its history has the tawdry quality of a royal soap opera. There

were those embarrassing rows when Monsieur, the King's pathetic brother (Vita Sackville-West called him "a prinking shrimp of a prince"), fought with Madame, his wife, over who would get to wear which jewels to a ball. Or the "horrible scenes in the pleasure-palace" the night Monsieur died. Everyone, including the King, rushed over helter-skelter from nearby Marly, where Saint-Simon was gleefully recording the comedy. After Louis had been assured that there was no hope for his brother and had returned to Marly, where he slaked his guilt by singing opera prologues with ladies of the court, Monsieur was laid out to expire. He was placed on a day bed in his study, according to Saint-Simon, "exposed to view of all the lackeys and under-servants . . . who rent the air with their cries, while the women ran hither and thither with their hair unbound, shrieking and wild as bacchantes." In the next room, his wife, the fat German princess, interposed her aria by repeatedly screaming, "No convent for me! Do not speak to me of a convent," and promptly drove off to Versailles as soon as her pathetic husband had breathed his last.

Earlier, there had been stronger stuff than comedy. St.-Cloud, the saint who gave the place its name, was a grandson of Clovis and had fled there to escape his uncles, who had murdered his brothers. Later, the village was put to the sword by the English, led by Edward III after the battle of Poitiers. Henri II's interlude using the place as a royal country retreat was apparently uneventful, but his Italian-style residence became the setting for Henri III's Italian-style assassination in 1589.

Among Marie de Medici's entourage had been a family of ambitious Italian bankers, the Gondis. Jean de Gondi managed to buy the place in 1625 and sometime later built the first cascade. Water at St.-Cloud was ample and had supplied the gardens of the Tuileries, where Catherine de Medici had had it conveyed by aqueduct in 1564. "Nothing is more esteem'd," John Evelyn wrote when he saw "the casada falling from the Greate stepps into the lowest and longest walke from the Mons Parnassus," during his visit in 1644. Artificial waterfalls had already become a major feature of Italian gardens and were placed on the side of the abundant hills that were favored for gardens. The cascades of the Villa Aldobandini and the Villa d'Este at Tivoli were famous and had been endlessly drawn and engraved by artists. Fountainebleau had its water piece by 1610, and in the 1630s the Cardinal de Richelieu had built one at Rueil. Some had large basins or nymphaea at their base like the one at Vaux, where Madame de Sévigné would stop on her way to Paris to bathe in "the ornamental waters." In an engraving of the nymphaeum at Maisons, you can see elegant, naked seventeenth-century nymphs sporting in the waters at the foot of the terrace.

Apparently when Bernini had been in Paris to work on his abortive plans for the addition to the Louvre, he had also submitted a design for a new and more fashionable cascade scheme for St.-Cloud. Earlier, he had created a rustic waterfall at Tivoli, piled up with all those baroque boulders, and it was something like Tivoli's cascade that he may have had in mind at St.-Cloud.

Shortly after Philippe d'Orléans, called Monsieur, had acquired the Gondi estate in 1658, he named Antoine Lepautre his personal architect. The first project was a new cascade and the elaborate hydraulic system that went with it. Unlike the horizontal, classic cascades at Vaux and the Château de Liancourt, the hillside at St.-Cloud invited something more theatrical and noisy like its exhibitionist owner. You approach it at the end of a long corridor bordered by heavy groves on either side that seem to hold the aggressive, violent waters to a more antique decorum as they descend over the backs of the frogs, turtles, and stone steps. Everywhere, nature is artificial, stylized, pitiless, and Lepautre's creation would make the perfect setting for a Racine tragedy or the backdrop for the massacre of all those Poussin infants.

Garden theatrics were nothing new to the royal neighborhood of nearby Meudon and St.-Germain-en-Laye. Dr. Lister called the district west of Paris *"les berceau des Roy,"* the nursery of

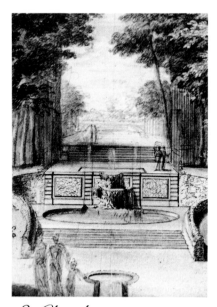

St.-Cloud

Seventeenth-century view of gardens.

kings where the "palaces and their gardens possess a barren and hilly country as big as most counties in England." Henri IV's St.-Germain, where Louis XIV was born, was pure theater of grottoes, fountains, and water tricks introduced by the Italian fountaineers the Francinis. Thomas Francini later worked at St.-Cloud, and it was his old, outmoded garden designs that were later remodeled by "that admirable contriver Mons. le Nostre." At Meudon the original palace was in fact a huge classical grotto dramatically placed on the side of the hill. Pastorals were staged in front of it, and on one occasion Pierre Ronsard, the poet, declaimed his own lines celebrating the Grotte de Meudon's antique beauty.

When Dr. Lister visited St.-Cloud, its garden and park had indeed spread over what appeared to be a fair-sized English county. It required a good meal and coach before setting out to see all the sights. *"Le promener à cheval ou en carrosse* is not English," he remarked as he was driven around the gardens by his host. "We cannot afford to lose so much country as those gardens take up." But that was before Kent and Brown had ingeniously hit upon the revolutionary scheme of merging countryside and garden into one vast plan.

The reclining figures of the Seine and the Marne at the top of the cascade which so attracted Atget's eye were not there when Lister made his visit to the cascade, though earlier versions of the river-gods did preside over the cataract from the balustrade. The "cascada" had actually been built before the château which was later placed on the hill behind. It was destroyed in 1870 and is now marked only by a series of flower beds.

Elizabeth-Charlotte, Monsieur's widow, her enemies called her "Madame Palatine," did not go to a convent and continued to live on at St.-Cloud after her husband's death and to write her endless letters until she died. Saint-Simon claimed she spent her days in a small room with windows ten feet above the floor so she would not have to look out upon French soil. And even though their son, the Duc d'Orléans, who became the Regent, used it as his residence, St.-Cloud's more eccentric moments had seemed to pass. The Regent's notorious supper parties were held at the Palais Royal, leaving the gardens to the endless throng of visitors who continued to stroll, to gawk at the cascade, and to gaze across the river to the capitol.

In 1785 Marie Antoinette, having tired of the make-believe country life of the Petit Trianon and "the pleasures of wandering about all the buildings of the Hameau, of watching cows milked and of fishing in the lake," was given St.-Cloud by the King, who had grown weary of her complaints about the dampness at Rambouillet. The air was better there than at Versailles, and it might improve the delicate health of her ailing son, the Dauphin. Micque, her architect, designer, gardener, and interior decorator, anticipating similar services for the rich and bored in the twentieth century, came along to remodel the château and had planned to add a fashionable *jardin anglais.* Even during the Revolution, the gardens were open to hordes of Sunday visitors. Gouverneur Morris, the American envoy, went there in 1791 and complained in his diary that "the garden would be delightful if laid out in the style of nature," instead of the "perfectly French" design.

Though neither rich nor bored at the time, Napoleon immediately directed his architect-decorators Percier and Fontaine to perform yet another face lift on the old apartments when he suddenly decided, in 1801, to make St.-Cloud la Maison du Premier Consul. Before the divorce, Josephine, now *l'impératrice,* had moved into Louis XVI's old quarters. Marie-Louise, who followed her, had little interest in altering the decor. The King of Rome was born there, announced by a magnificent fête complete with an illumination of the cascade. After Napoleon's fall, General Blücher, who moved into the palace, put his dogs in the Empress' boudoir.

As one tawdry reign followed another in the nineteenth century, the life of St.-Cloud became

St.-Cloud

Nineteenth-century view of terraces.

even more trivial. The reign of Napoleon III was the most extravagant and vulgar, remembered for the torch-lit procession and the illumination of the cascade to welcome Victoria and Prince Albert as well as for all those comfortable chairs and sofas used by Eugénie, combined with rediscovered eighteenth century furniture, to decorate the great salons. It would probably have been better if the mobs of the Revoluton had fired the château, an ending that might have been ennobled in time instead of recalling the defeats and the embarrassments of the end of the Second Empire. Its destruction—both French and German accused each other—was apparently without much point and ambiguous like its history when it was burned in 1871 after the Emperor and his Spanish Empress had departed for good. They left behind unequaled views and the waters of the cascade that still play on certain days.

Sceaux

"To study the suburbs is to study the amphibious animal," Victor Hugo wrote in *Les Misérables*. "To roam thoughtfully about . . . in that rather illegitimate species of countryside which is tolerably ugly but odd" is a school for a philosopher. The point where the energy of a great city like Paris meets the countryside resembles the confrontation between land and water. There is an opposition and tension, a conjunction of elements, that creates a kind of limbo for both nature and the man-made environment. Perhaps one should speak of this suburban zone of Paris in the past tense, from the point of view of a Hugo, Zola, or Atget, for that enigmatic line is badly blurred, if not destroyed, now in the wash of twentieth-century urban sprawl.

Hugo's world of the *bainlieus,* "these solitudes contiguous to our *faubourgs,*" where the roofs and pavement ended and the trees and grass began; the beginning of the shops at the end of the furrows; the noise of the crowd drowning out the "divine murmurs" of the countryside; the onset of passions at "the end of the wheel-ruts" is precisely that "illegitimate," vague, mysterious stretch of habitation that attracted Atget. Hundreds of his plates sold to the École des Beaux Arts document the Parisian suburbs. It was here in the "harsh monotonies of waste" of Paris suburbs that Atget frequently prowled with his camera along the deserted streets, quiet gardens, cemeteries, and former villages, now merged with the city and where he found some of his most haunting visual souvenirs. In 1900 the former Domaine de Sceaux, half forgotten on the southern circumference of the city's edge, provided Atget a landscape of extravagantly romantic beauty.

In 1673 Colbert, that master planner of national life and grand manipulator on behalf of the glory of France, built the Château de Sceaux just southeast of Paris on the road to Orléans. It was around this estate of the superintendent that the later suburb of the nineteenth and twentieth centuries, named after the château, developed. Le Brun and Le Nôtre, who had just worked together for Nicolas Fouquet at Vaux-le-Vicomte before moving on to Versailles, were given major artistic responsibilities. It is ironic, but typical of the era, that Colbert, who had engineered Fouquet's destruction because of his extravagance, used the same talented designers that Fouquet had made famous. In the months preceding the fatal celebrations at Vaux, it was Colbert who meticulously went over Fouquet's doctored accounts each evening and reported them directly to the King. The young King was being robbed right and left and not only by ministers like Fouquet, but in the administration of royal buildings as well. It was to reform all of this incredible waste that led Colbert to set up a system of architectural and artistic commissions enabling him to control the royal

buildings, architects, and contractors down to the last sou. The Academies of Sculpture and Architecture were created to join the Academy of Painting. It was to this highly organized body of talent that he turned when he began his own retreat at Sceaux. All the great artistic names of the period, including Perrault, Girardon, Coysevox, Tuby, and Lepautre, who had designed the cascade at St.-Cloud, were associated with the project.

Yet Colbert, for all of his new power and wealth, was careful not to set himself up in the flamboyant, baroque splendor of Fouquet's Vaux.* The château, as well as Le Nôtre's gardens at Sceaux, were marked by the restraints and sobriety of an accountant's taste, judging from Jacques Rigaud's engraving of the now vanished château. Only the handsome and severe entry gates and pavilions of Colbert's original building remain to frame the present nineteenth-century stockbroker's mansion that stands on the site of the château.

The countryside, valley, and rolling hills around the château gave Le Nôtre one of his few opportunities to design a new garden rather than to remodel earlier layouts like Chantilly, St.-Cloud, the Tuileries, and, of course, Versailles. The chief structural legacy of his design was the long avenue running from the château to the large octagonal basin at the foot of the hill, an avenue that Atget photographed many times and at different seasons during his lonely rambles in the park. Much of the work on the gardens and park was actually carried out by Colbert's son, the Marquis de Seignelay, who finally sold the estate to the Duc du Maine in 1700 for 900,000 livres.

The crippled Duc du Maine was not only Louis XIV's favorite bastard, he was probably his favorite among all his offspring. Like his mother's family, the Marquise de Montespan, he was amusing, a great talker and a dissembling charmer, at least to those he wished to charm. But unfortunately he suffered from cowardice. Saint-Simon called him "the biggest coward and busiest schemer imaginable," and as Nancy Mitford remarked, cowardice was the one eccentricity not tolerated at Versailles.

In 1692 the duke was married to Louise Benedicte de Bourbon, granddaughter of the Grand Condé, and it was her fabled court, supposed vices, and long reign that are recalled at Sceaux. The future duchess, like her sisters, was virtually a dwarf. When the club-footed Duc du Maine came to choose among the daughters of M. le Prince—they were known as the "dolls of the blood" instead of the princesses—he reportedly picked his wife because she was a fraction taller than the rest of that diminishing race of the Condé.

No sooner were they married than the little duchess (Saint-Simon said she was "intriguing, bold, quarrelsome") began to badger her shy, timid husband into setting her up in grandeur and power befitting her station. She did not hesitate to remind the duke that he had married beyond his own. Colbert's old retreat was to be her sovereign domain, her Chantilly, her Versailles, her St.-Cloud in miniature. After all, it did have a cascade and a canal, splendid *allées,* fountains, and numberless white statues and urns. It is the sad wreckage of all of this park and its gardens, which was continually enlarged and improved throughout the eighteenth century, that Atget sought out and explored.

Being a bastard of the King, it was difficult for the Duc du Maine to secure permission to marry. "Such persons ought never to," the King remarked. He foresaw the terrible political confusions and conflicts that would inevitably follow the creation of what Saint-Beuve called "this

* He did, however, like the King, have his *trophée de Vaux.* Fouquet's monumental copy of the Farnese *Hercules,* which was planned as the focal point on the far hill opposite the château, was not completed at the time of Fouquet's fall. Colbert later acquired it from the sculptor Puget and placed it *l'avant du château* at Sceaux. It did not survive to be recorded by Atget.

equivocal race," of legitimized bastards. Toward the end, the King, tired and old, yielded to all of the pressures to legitimize his natural offspring—"enhancing the glories of bastards"—thereby setting up visions of future glory for the residents of the tiny Fool's Paradise at Sceaux. It had never occurred to them in their splendid isolation that even an Orléans, the Regent, would have the boldness and cunning to dispute and finally nullify Louis's dying commands.

In the meantime, "Sceaux had become the scene of the ever wilder follies of the Duchesse du Maine," sniffed her enemy Saint-Simon, who deplored the elevation of the bastard line to a place of royal equality that might eventually lead to the throne itself. "Her house was a perpetual source of amusement for Parisian Society. She spent entire nights with lotteries, gambling, feasts and fireworks." Her intimates claimed that it was insomnia that required such long hours. The duchess' friends called them "The Diversions of Sceaux," and in the grounds of her pastoral retreat, she appeared in her favorite theatrical roles, giving one season, for example, *Athalie* several times a week with a cast of professional actors. The whole thing was one long masquerade, playing shepherdess, inspiring impromptu madrigals, staging *grand nuits,* charades, and ballets. These scandals became more notorious as the legitimate heirs to the throne continued to die off, bringing the bastards one step closer to succession. The charge of incest with her brother was spread about in witty and indecent street verse. But as Saint-Beuve observed, "such fancies were not rare in the family of the Condés." The madness of the Condés was famous. When the uncle of the duchess thought he had died and refused to eat for the obvious reason that the dead do not need to, his doctor had ingeniously introduced him to a group of "dead" friends who came and joined the duke for dinner, breaking the fast and saving his life.

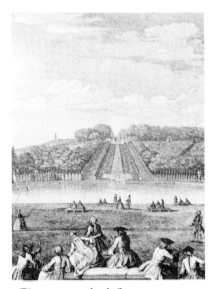

Bassin de l'Octogone

It was always the duchess who planned the strategies for her dreams of power, and it was she who summoned some dukes to Sceaux to talk over "eventualities" on the eve of the Regency, a few months before the King died. Ambition at Sceaux, someone said, always lurked just below the surface of all the games and comedies. But her husband lacked the mettle of his pygmy wife. She called it a "lamentable want of spirit." The crippled duke was terrified both of the prospect of reaching the throne and of his wife's schemes, who threatened him with her own madness if he did not follow her misguided management. "M. du Maine . . . dared not oppose her," Saint-Simon wrote, "for fear of her brain turning." The King, having been nagged into changing his will, placing the Duc du Maine and his brothers in the line of succession, the duchess' plan was to secure a base in Parlement to protect her husband's rights once the King was gone.

Her treasonable overture, masked with a flow of compliments made to the potential allies invited to the château or with greater privacy in the far reaches of the park as they walked along the avenue toward one of Atget's statues, was not taken seriously by her visitors. Or perhaps it was too serious, for with all the notorious civic madness of the Condés, a proposal to gain the throne was an act of patriotism as far as the duchess was concerned and was not to be ignored. If her plan failed, the dwarf duchess declared she would not hesitate to "set the kingdom on fire from end to end." Her guests' retreat from her proposed conspiracy, covered by glazed eyes, more compliments, and a slight stiffening of shoulders, threw her into a rage. Wilder schemes followed, leading finally to the arrest and imprisonment of the tiresome pair by the Regent. The easygoing Regent did not carry out the arrest, however, until three weeks after he had received proof of the treason, so they would have time to destroy the most serious evidence they had hidden in the closets of Sceaux, thus relieving him of the embarrassment of imposing even worse punishment. Returning to Sceaux after her humiliation, where her château was still standing in its park some three hundred feet above the valley, it nevertheless must have appeared like a mountain to its tiny chatelaine. In order to forget

her defeat, the duchess once again threw herself into a life of noisy and busy escape. At seventy she was still taking the role of a virgin shepherdess in one of her plays.

Voltaire came often to Sceaux and was lionized by Mme du Maine's little court of fantasy and delirium. Once, after he had barely escaped from Paris following one of his habitual provocations, the duchess had hidden him in a remote apartment in the château where he lived and worked on a play by candlelight for two months behind closed shutters. When she was seventy-six, he wrote a friend from Berlin telling him how he longed to be "at the feet of Mme la Duchesse . . . hers is an elect soul; she will love comedy to her last moment, and when she falls ill, I advise you to administer some fine play to her instead of Extreme-unction. People die as they live. . . ."

For all of the fun and exertion at Sceaux, the wit and the petty cruelties—the Prince de Ligne remarked that the duchess had "a twist to her mind as well as her shoulder"—the spoiled and easily intimated circle of courtiers filling the duchess' vacuum was third rate. "The desire to be surrounded increases," her companion Mme de Staël wrote to Mme du Deffand from Sceaux. But this did not include the court, for unlike Louis XIV, who habitually stopped overnight on his way to Fontainebleau, his successor never came near the place. No longer were there lines of carriages stretching all the way back to Versailles itself as on that Saturday in December 1700, when Louis and the Spanish ambassador drove through the park of Sceaux to say a final farewell to Duc d'Anjou, who was then sent off to be the King of Spain.

The Duchess du Maine finally died in 1753, and the original château was destroyed during the Directory after it had been owned by the Duc de Penthièvre. The present one, built in 1856, though smaller, stands on its site. The park itself was used for a school of agriculture in the nineteenth century. The Pavillon de l'Aurore and the Orangerie, where the duchess had staged Racine, Molière, and Lully, later became popular restaurants in the Second Empire. The park was too large to be maintained, and it continued to be rented out well into the present century falling into that neglected suburban tangle of overgrown walks, silted basins, and dry fountains that Atget photographed. His ancient alleys, with their trees leaning into a long Gothic vault and intersecting the immense waste of the park ending in those poignant wheel ruts, somehow define the limits of Sceaux's imprudences. One can imagine in Atget's views, far better than the actual place restored as it is now, the tyranny of the Grand Condé's granddaughter, scheming day and night to stir up a new Fronde against the Regent. Even now, and we see it even more clearly in Atget's images, the terrible void, the emptiness of the place, presided over by the ghosts of those two deformed creatures, fighting against the onset of that chaos with endless suppers, plays, balls, diversions of every kind, to keep out the desolation that Atget would later savor with his lens. But the duchess' sense of hopelessness was too desperate to hide even with her tyranny of madness. How else to explain her heartless remark that she suffered "the misfortune not to be able to do without persons for whom I care nothing at all." They were there to fill the vacuum, to defend against the void that threatened on every side. "She hears with indifference of the death of those who, if they kept her waiting a quarter of an hour for a walk or a game or cards, would make her weep."

After her imprisonment by the Regent, we see her again back in her enclosed gardens, a tarnished and ancient child of seventy, playing out her comedies before a bribed assembly in a tiny fairyland of impeccable flower beds, raked walks, and great prospects extending out over the canal. In a way, she reminds us of those strange, instructive children of Hugo's suburbs—quarreling, irresponsible, volatile, eternally truant, but with "poignant graces . . . playing hide-and-seek and crowned with corn flowers," whose little world on the periphery of Paris was no larger than that of the duchess and just as isolated. "In the evening they can be heard laughing. These groups, warmly

illuminated by the full flow of midday or indistinctly seen in the twilight, occupy the thoughtful man for a very long time, and these visions mingle with his dreams."

In reply to some gossip about her conduct, her eccentricities, and her absurdities, the Duchess du Maine wrote, "Princes were in the moral world what monsters were in the physical: we see openly in them the vices that are unseen in other men."

Arcueil

On the suburban train running south toward Sceaux, you can see from your window just below the station of Arcueil what appears to be the remains of a Roman aqueduct. At a distance, it appears better and somehow more elegant than those fragments around Rome, recalling the superior remains found in Spain or Yugoslavia, though much of its superstructure is actually nineteenth century.

Even though the former village of Arcueil is now well within the modern orbit of Paris, it still has some of the qualities of Victor Hugo's isolated nineteenth-century suburbs, "two leagues beyond the barriers," those "not very attractive places, indelibly stamped by the passing stroller with the epithet *melancholy*, the apparently objectless promenades of the dreamer."

Atget may have discovered Arcueil and its historic aqueduct during his trips back and forth to Sceaux, or he might have followed the ancient rue St.-Jacques out to the edge of the city where Marie de Medici's water system had once continued on its way from the Rungis to the gardens of the Luxembourg. Naturally, the Italian Queen needed quantities of water for the fountains of her new gardens, so after the King, Louis XIII, had inspected the source to be sure it was adequate, he laid the cornerstone in 1613. Eleven years later, water finally reached the conduits of the garden itself. The architect of the Luxembourg, Salomon de Brosse, was undoubtedly involved in the design of the classic structure, although the Italian fountaineer Thomas Francini, who had built the fountains for the Queen Mother's gardens, also worked on it. Its fine antique lines can still be seen beneath the nineteenth-century additions.

Atget was not the first artist to be attracted to the picturesque setting on the little river Bièvre. Here in the gardens of the Prince de Guise, the eighteenth-century artist Jean Baptiste Oudry had discovered the same compelling contrast of nature running wild within a formal landscape structure that had drawn Atget to Sceaux and other former royal parks. The steep hillside the prince had selected for his garden, with its Roman backdrop of the soaring arches above his terraces and garden stairs, was more Italian in feeling than anything seen before around Paris. In the 1740s when Oudry worked there, the place was already overgrown, trees pushing into walks, broken statuary and balustrades tumbling everywhere, with clear signs of imminent decay, like the more ancient classical sites of Rome itself or Atget's later photographs of Sceaux. The Prince de Guise's park with its ready-made props became a kind of outdoor art school, and Oudry shared his privilege of entry and enthusiasm with younger artists like Portail, Natoire, Boucher, and Pierre Wille. It was for them what the gardens of the Villa d'Este at Tivoli were to be for Fragonard and Hubert Robert a few decades later and what Le Brun's romantic Montmorency had been for Watteau earlier. In Oudry's landscape drawings, his sense of composition, the searching realism rendered with unique skill by simply combining black chalk and white body color on blue paper, a common kinship to the photographer, if not influence, is detected.

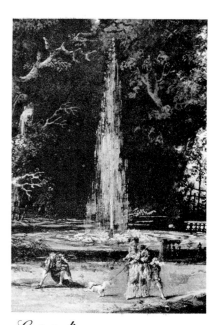

Le jet d'eau

By Moreau (detail).

By the time Atget knew Arcueil, the garden had long since been abandoned and working-class houses had filled the spaces beneath the span of the aqueduct and the somber walls of the Prince de Guise gardens. Still, there were plenty of trees and stretches of countryside beyond, not yet taken over by grimmer monuments of the twentieth century. A record of that junction between city and plain, nature and humanity, wheel ruts and passions, can still be seen in Atget's Arcueil folio.

Sometime in the summer of 1927, Berenice Abbott, who had taken up portrait photography in Paris, persuaded Atget to sit for his portrait. A few days later when she took the prints of the old man in an overcoat around to his studio, his sign, "Documents pour Artistes," had been removed. Only then did she learn that he died. He had been quietly buried a few days before in the cemetery of Bagneux, next to Arcueil.

City Gardens

Hiding his obsessions behind his camera, his isolation almost complete beneath the black cover as he concentrated on some detail of the city, Atget pierced the very essence of its topography. The great public spaces of French civilization itself—the Tuileries, the Luxembourg, the Palais Royal—lay in his daily path. Those trips back and forth across the city became the subject of his wordless history.

Like any good historian, he always wanted more documents than he could really use or knew what to do with. The idea that he would sell his photographs to friends, artists, or even strangers, was a subterfuge, a cover for his true concerns. It was an empire of "things" he was gathering; the history of a city in its smallest details; a remembrance from the past like so many prehistoric flies in amber sealed beneath the unfortunate silver bromide in which he coated his plates and thinly printed on the gold chloride paper.

The things that Atget was interested in so often seem to be threatened. Not only is this true of the architecture and gardens, but it includes his interest in the small craftsmen and shopkeepers of Paris. At the end of the century the inevitable demise of the ancient handcrafts that had long been a part of the city's life was apparent. Industrialism and technology, which had produced the camera, destroyed or damaged in its wake the old professions, like miniature portraiture and engraving. It also proclaimed the downfall of craftsmen in other fields, and Atget turned to these threatened species in much the same way as he had to old buildings. They were all a part of an end of an era which he felt compelled to document with an instrument that symbolized in a way the source of that destruction.

From the outline of the clamps of the plate holders on many of his prints, it is clear that he had composed his photographs to the very edge of the plates. Since he had no filters, he would often work in the parks on wet days in order to capture different effects of the sky, though they are usually without clouds. Trees, even more than statues and urns, seemed to absorb his attention, often dominating the architecture or sculpture, the ostensible subject. Abbott said that Atget's trees "represented all the trees of time."

"In the gardens of the Tuileries he had lingered. . . ." There is a fitness to that line from *The Ambassadors* that somehow sums it up whenever we think about the place and especially of Atget lingering there with or without his camera staring at some infinitesimal detail. Even with all the tourists and students, the derelicts, the children, the *flâneurs*—"the seeker after something or other

. . . with his *angst* and his foggy modern eye," as Eleanor Clark put it—in the Tuileries one still feels close to the epicenter of not just France, but urban civilization itself. It has "so much of the superb, so many proofs of a civilization," Hyacinth muses in *The Princess Casamassima* on his first visit.

The Tuileries is, like Rome's Campidoglio, the starting point where strangers gather their first impressions of the city and where you can best adjust the eye and the ear, like a great decompression chamber, to those first disorienting moments when you arrive. For not only the senses but the mind itself can reel before the insidious language of Paris, and not just that language one hears and speaks or tries to. The city makes up its own vocabulary and speaks its own language, and in part it is that wordless language that Atget attempted to translate through his visual metaphors numbering thousands of images in his dictionary.

The first ground of what is now the Tuileries gardens, just west of the Louvre, was purchased in 1519 by François Premier. This was where the feudatories of the crown in medieval times had been forced to assemble from time to time to renew their oath to the King. François had bought it as a kind of suburban retreat for his mother, Louise of Savoy, whose poor health required her to seek *"en belle air et en belle situation."* In 1528 the King began a new palace at the Louvre, and for centuries it would command the best architects of the realm in its endless building and rebuilding. Later, the Italian-born Queen, Catherine de Medici, added to the royal real estate holdings in the 1560s when she proposed to build her own palace on the site of Louise of Savoy's old house near the river, a short distance from François's Louvre. After the work had begun, it was abruptly halted by the superstitious Queen who had—in the interim—consulted her astrologer.

Before Catherine, now the Queen Mother, had abandoned the work, however, a stiff and considerable park following roughly its present historic lines along the river had been created for her new, but unfinished, Tuileries palace. Water was brought from St.-Cloud for the fountains and Bernard Palissy, that mad potter and *grottoiste,* worked diligently on the Queen's grotto, built on an island and reached by a faïence-covered bridge. There was also a labyrinth, an elaborate menagerie, and an aviary to entertain visitors.

Following the massacre of St. Bartholomew's Day in 1572 and the fighting in the gardens themselves, which had caused extensive damage, order was sufficiently restored a year later for Paris to be once again *en fête.* It had been a part of the Queen Mother's subtle policy of détente to stage a "magnificence" whenever factions threatened to upset the uneasy peace as a means of diverting the warring factions around the court, and many of these were staged in the Tuileries gardens. There were those who thought her fête on the eve of St. Bartholomew, however, to have had more sinister intentions.

In August 1573 the ambassadors from Poland arrived to offer the crown of their country to Catherine's son, Henri. We can see Catherine there in the Valois Tapestry, which now hangs in the Uffizi, with the gardens behind her as she dominates the scene in her widow's weeds. A court ball is in progress. The chair next to the Queen is empty, for her son, the King himself, has joined the dance. It is the myth of the garden ideal, interrupting for a brief moment, with brilliant costumes, music, and ballet, the terrible, bloody reality of that terrible age. There were those there at the Polish entertainments who had good reason to be suspicious and uneasy with memories of the Queen Mother's fête the year earlier. Those festivals in 1572, celebrating Catherine's daughter's marriage to Henry of Navarre, signaled that night the murder of most of the Huguenots assembled in Paris for the wedding.

Henri IV completed Catherine's palace and rebuilt the gardens, though its spine, the central

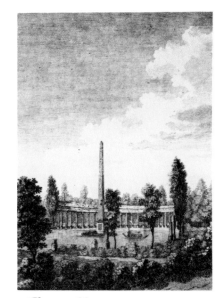

Parc Monceau
Naumachie.

33

avenue running to what is now the Place de la Concorde, was maintained and widened. "I finished this day with a walke in the great garden of the Thuilleries," John Evelyn noted, not many years later, in his diary in 1644. It was, he observed, "rarely contrived for privacy, shade or company by groves, plantations of tall trees, especially that in the middle of being elmes, another of mulberrys." He was also impressed with the fountains, fish ponds, aviary, and the "echo, redoubling the words distinctly and it is never without some fair nymph singing to it." The King's falcons were kept in the aviary and swans floated upon *l'étang aux cygnes.* Still the basic plan was conservative and rigid in spite of the hidden pleasures. Even Jacques Boyceau, the formal gardenist par excellence, was provoked to declare that "it is wearisome to see so many rectangles."

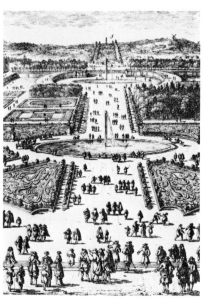

The Tuileries

Le Nôtre, whose father and grandfather had worked in the garden, was born in a house on its northern edge. Before he turned all of his attention to the Versailles gardens and his other landscape projects, he completely redesigned what had become a family cynosure, establishing the *grandes lignes* as we still know them. In the northwest corner near the rue de Rivoli, he created a marvelous outdoor theater with green walls of clipped hornbeams.

The Parisians have always had a deep affection for their public gardens, and even early foreign visitors seemed to be impressed by their conspicuous strolling, carousing, love making, and begging. "Gay promenaders, sidle and shift among the branches," while others keep to their newspapers and chairs, "among the marble Atalantos, Apollos, Daphnes and Satyrs," wrote one English lady on her first visit. It was no different when Atget went there with his camera or even now, for that matter. The public's ritual was so well established that an astonished Arthur Young, in 1790, witnessed Louis XVI walking in the gardens unattended through the tricolored revolutionary crowds who cheered and politely gave way to majesty. His Austrian Queen was seen to lead the royal children to one of the ponds to feed the ducks while her Parisian critics and enemies stood by and applauded.

At one point, in the seventeenth century, an attempt was made to close off the new terrace running in front of the palace for the exclusive use of members of the court. The public outcry was enough to force the powerful Colbert, the author of this outrage, to rescind the order. On the terrace running parallel to the river the five-acre Jardin de Renard actually had a restaurant as early as the seventeenth century, and Evelyn saw "so many coaches, as one would hardly think could be maintained in the whole citty."

Trees of every kind were set out in the Tuileries and were the ancestors, at least, of those descendants photographed by Atget. Henri IV tried cypress, but these were killed in the great freeze of 1608. In the Cours-la Reine in 1628, Marie de Medici had planted some strange new species introduced into France from India by Richelieu and known then in his honor as *cardinals* and to us as horse chestnuts. Evelyn recorded pomegranates, elms, maples, and cypress in his notebook. The long arbor of "maple trees wherewith the walke is on both sides beset, doe reach up to the toppe of the roofe, and cover it clean over," wrote an impressed Thomas Coryat when he saw it in 1611.

A short distance from the Tuileries there is another piece of ground, an open space, though not as large, that is also filled with the titillations of history. Atget knew very well the present spacious gardens of the Palais Royal surrounded by its arcaded galleries recalling the Piazza San Marco. When he first went there, the present, but much altered garden, laid out in 1781–84 and containing six acres, was about one hundred years old. It had been contructed for the Duc de Chartres on the site of Cardinal Richelieu's original hotel begun in 1629. "The house of a great magnate," Blondel wrote of the earlier Hôtel Richelieu, "should show unmistakably that it was not the house of a mere private gentleman." If its exterior was heavy and a bit too anonymous to meet

Blondel's standards, the gardens and the theater left no doubt about "mere private" gentlemen. As a princely host, the cardinal-dictator could seat three thousand spectators in his private theater. Music was an important part of the cardinal's entertainments and he would frequently borrow the King's orchestra, *"les vingt-quatre violons."*

Atget, the actor, would have known the precincts of the Palais Royal from the moment he arrived in Paris, for it continued to be the center of the theater district following Richelieu's original example. The Comédie Française is actually in a corner of the palace, and Atget's friend Victorien Sardou's plays were produced there. By then, in the 1880s and 1890s, the palace and gardens had become sedate, institutional, and chaste, like an old courtesan trying to hide her past. In Atget's day, as in our own, utterly nothing of its former "bustling dissipation and lounging sensuality," the noise, the crowds, "the loose and desperate spirits" survive in the empty bureaucratic space that is now closed to the public. It is its older Soho and Forty-second Street reputation that is recalled in the endless letters, diaries, and reports on the Palais Royal over the centuries. "Prostitution dwells in its splendid apartments, parades its walks, starves in its garrets and haunts its corners," ran the account of one Philadelphia visitor, as if he were writing the travel copy for a porno magazine. "There is but one Palais Royal in the world," he concluded in relief, "and it is well for the world that there is but one."

Richelieu had built in the gardens of his hotel a toy fort for his charge, the Dauphin, later Louis XIV. An engraving shows an elaborate miniature fortification that would turn the most retiring boy into a teen-age field marshal. It was Louis who later gave the palace to his brother, Monsieur, making it the city headquarters for the Orléans family, housing their ambitions, their vices, their grandeur, for the next hundred years.

The future Regent, the Duc d'Orléans, grew up there when he wasn't at St.-Cloud, and he seems to have loved the place from an early age when he wasn't dodging his father's favorites who hung around gossiping, giggling, and making suggestive remarks in the young duke's direction. It was here that the Regent later staged his own orgies that put the memoirs of the Regency in a special literary category. His mother, Madame, attributed her son's vices to the fact that young women had given up wearing corsets rather than to any inherited inclinations.

Quite often the Regent's notorious suppers were held at the Luxembourg as a change of scenery for the jaded company on the other side of the river where the Regent's daughter, the Duchesse de Berri, upheld the family's eccentric traditions. Her parties were enough to intimidate even the lecherous and drunken Peter the Great, who refused a second invitation to the Regent's entertainments because the conversation and behavior of his fellow guests were "too free."

On the eve of the Revolution, the garden of the Palais Royal had become a kind of city within the city, the "capital of Paris," Sébastien Mercier declared. "There you can see everything . . . a prisoner could live here free from care for years with no thought of escape." When the future "Philippe-Égalité" began his real estate development around the garden in the 1780s, he had approached the job like any good shopping mall speculator, throwing old tenants out, acquiring new properties, and turning the whole thing into a successful commercial and entertainment complex. Like the good spoiler that he was, he did not hesitate to cut down trees in all directions. Mme Piozzi complained that the duke had "removed a vast number of noble trees, which it was a sin and shame to profane with an axe, after they had adorned that spot for so many centuries." Beneath the center where the statue and ancient tree stand in Atget's photograph, the enterprising duke installed a subterranean circus built for equestrian exhibitions. Thomas Jefferson was so impressed when he saw it that he wrote friends in Richmond to consider a similar garden-shopping mall for the new capital

of Virginia. "A whole square in Richmond improved on some such plan, but accommodated to the circumstances of the place . . . would be very highly advantageous to proprietors, convenient to town and ornamental."

For all of its apparent civic propriety during the day and although admired by the Virginian, it was quite a different thing at night. The gardens became by late afternoon a place where, according to one contemporary description, even a "mother dare not cross the noisy galleries with her daughters; the virtuous wife, the honest citizeness, dare not be seen beside bold courtesans, whose finery, manners, bearing and often their words, force one to flee bemoaning the general corruption of both sexes."

"General corruption of both sexes" is an old complaint that one had heard about in more than one Paris garden, and the charge was not foreign to the Luxembourg, which Atget also frequented. He seems to have had a special affection for its later bourgeois garden life that one sees in many of his photographs where children, families, old men and women calmly enjoy its sedate, nineteenth-century air. One can almost hear an Offenbach medley being played in the background by the Sunday afternoon band beneath the trees, far removed from the scandals of the seventeenth century or the derelict German tanks that were found abandoned along the avenues in 1944.

The mutilations of the twentieth-century grounds of the Luxembourg at the close of World War II were in fact no worse than the work of the nineteenth or eighteenth centuries, which left nothing really of Marie de Medici's original fifty acres except the outline, more or less, of its original space. Its popularity also survived. The notorious Duchesse de Berri had tried to close the gardens after she had overheard provocative descriptions of her Luxembourg parties while walking there late at night to monitor public opinion. There was the usual public howl, forcing her to reopen them and to quickly retreat to her country estate, La Muette, until things cooled down. To Parisians, garden life was not something to be trifled with.

The Luxembourg gardens had been originally commissioned by Marie de Medici as a setting for her new palace, and she probably had the Bobli garden of her native Florence in mind when she commissioned Jacques Boyceau to lay them out. Like the Tuileries, the ground is rather flat, and Boyceau had to use his genius to give it any semblance of the irregular terrain of the Florentine garden model. Water was brought in over the aqueduct at Arcueil, and that helped, at least with the fountains of which there were a number. Water, as Le Nôtre and Louis were to learn, could hide vast acres of monotony and distract the eye from the routines of order.

The gardens now have lost the clean geometry that one sees in the seventeenth-century views. It seems, and it is in fact, much closer to the sticky air of the *fin de siècle* one sees in Atget's photographs. The corrupt isolation of the Senate, housed in the palace itself since 1879, seems to have broken the liaison that Boyceau envisioned between architecture and grounds in his original plans and so essential to French gardening. The garden façade one sees in Atget's view is a skillful nineteenth-century addition, designed by Gissors and built between 1836 and 1841.

When it was new, the Luxembourg vied with its chief rival, the Tuileries across the river, and Evelyn, in fact, thought it was better, both in design and in ambiance. "The gardens are neere an English mile in compasse," he carefully noted, "enclos'd with a stately wall, and in a good ayre. . . .Towards the grotto and stables within a wall, is a garden of choyce flowers, in which the Duke spends many thousand pistoles." Evelyn was particularly impressed with the "number of persons of quality, citizens and strangers who frequent it . . . walks and retirements full of gallants and ladys; in others melancholy fryers; in others studious scholars . . . some sitting or lying on the grasse, others running, jumping, some playing at bowles and ball, others dancing and singing." The

English student of urban life could hardly believe his eyes. Nothing in London, even on a balmy May day, had yet approached the sensual garden life, so special to the Parisians and cultivated as assiduously as the flowers in the parterres. It is still the privacy, variety, and intimacy of experience that is possible within the enormous space that even now gives the Luxembourg its special quality. Everyone seems to know what the place is for, what to do the minute he enters, like well-trained actors or dancers moving onto a familiar stage to perform a familiar role. The sound of gravel underfoot, the easy laughter, the splash of the the boat being launched into the basin echo with a domestic intimacy for all the open expanse.

During the Revolution, Marie de Medici's palace was turned into a prison of the *beau monde*. "It was an amusing spectacle," wrote one of the prisoners, "to witness the arrival of two marquesses, a duchess, a marchioness, a count, an abbé and two countesses, all of them in one wretched carriage." When the Convent of the Chartreux, which may have dictated the Queen Mother's original plans for the gardens by blocking her land acquisitions in their direction, was demolished in 1790, the gardens themselves underwent major remodeling.

The Palais Royal, about the same time, became the "Palais Égalité" during the Revolution, and its gardens suffered extensive damage before being restored to the Orléans family later in the nineteenth century. "It is in a state of ruin, compared with what it formerly boasted of grandeur," Fanny Burney wrote in 1802. "The river cut through it is nearly dried up from neglect of the fountains; the house is turned into cake-rooms, and common benches are placed in the most open parts of the garden . . . nevertheless, with all this . . . I . . . thought it probably more beautiful though less habitable than in its pristine state; for the grass wildly growing was verdent and refreshing, the uncut lilacs were lavish of sweets and nature all around seemed luxuriantly to revel over the works of art." Atget's old, gnarled tree may well be left from the "revels" of nature the romantic Miss Burney found so appealing.

The garden of the Tuileries ending on the Place Louis XV, though not damaged during the Revolution, was the backdrop for the public executions that took place in the square beyond. Two days before the attack on the Bastille, the American minister Thomas Jefferson crossed through a barricade near the entrance to the gardens, set up by the Prince de Lambesc's cavalry. "But the moment after I passed, the people attacked the cavalry . . . and the showers of stones obliged horse to retire," the Virginian blandly reported to a friend. Later, Jefferson wrote that following the attack, "the people now armed themselves with such weapons as they could find in armorers' shops and private houses . . . and were roaming all night, through all parts of the city, without any decided objective."

At the other end of the garden the revolutionary objective was somewhat more focused when the Commune fell in 1871, taking with it the Tuileries Palace itself. The National Guard on the night of May 23, outraged by the National Assembly's decision to move the government from Paris to Versailles, defended any attempt to stop the conflagration before retiring to the Louvre for a late supper while they watched what remained of Catherine de Medici's palace go up in thousand-foot shoots of flames. From the garden side, "millions of sparks rose, rained or rushed hither and thither." When the roof of the central pavilion collapsed, flames erupted, "imparting to the awful spectacle much the aspect of a bouquet of fireworks, such as usually terminates a great pyrotechnical display. . . ."

In the 1880s, when Atget first came to Paris, the black ruins of the palace were still there facing the gardens before they were finally removed and scattered around France to other parks as souvenirs. Like the ruins of St.-Cloud to the west, new flower beds took their place.

Tuileries Palace
Ruins—by Atget.

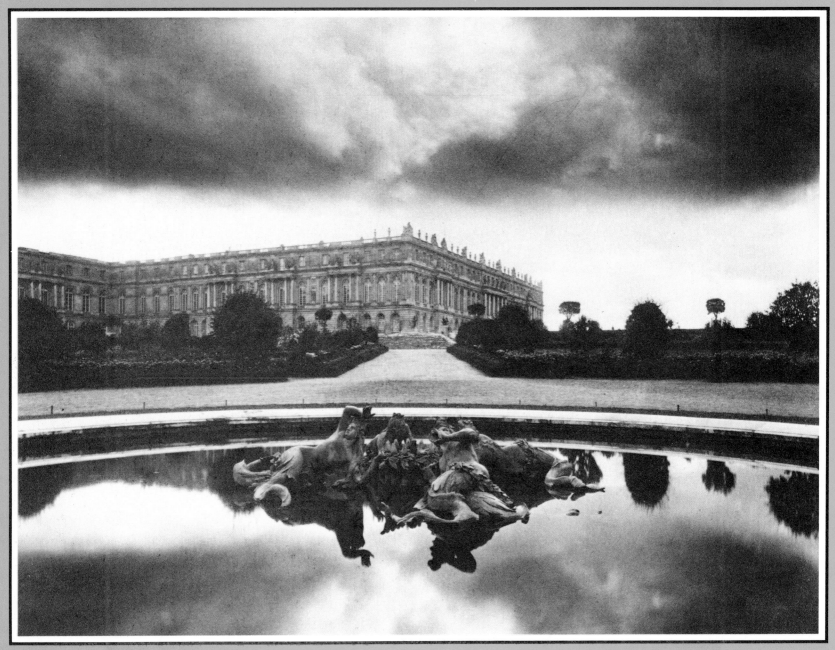

Figure 1

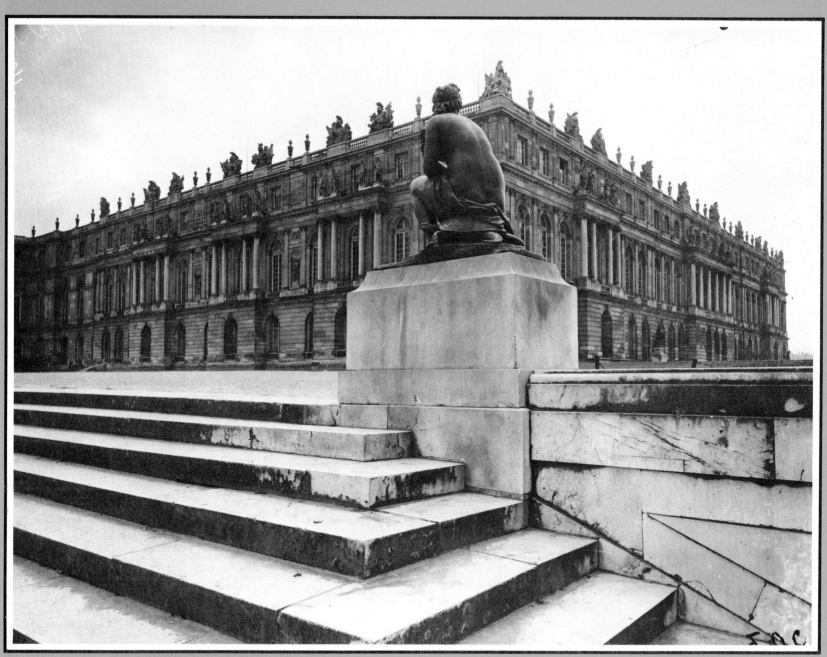

Figure 2

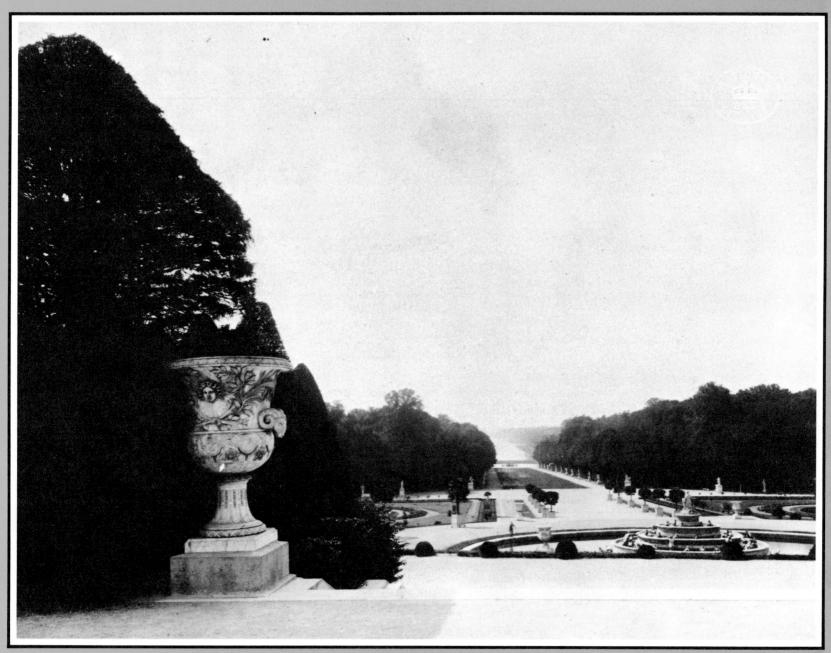

Figure 3

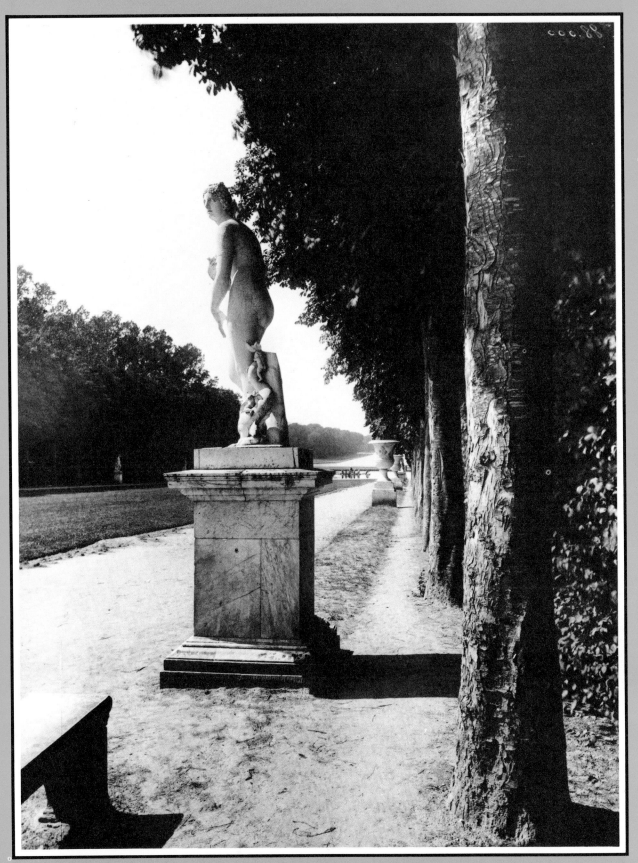

Figure 4

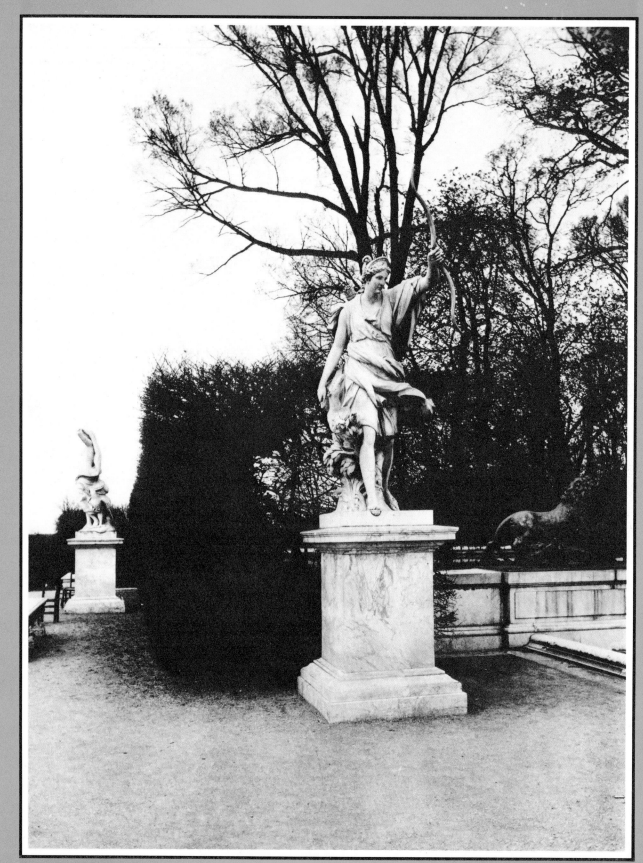

Figure 5

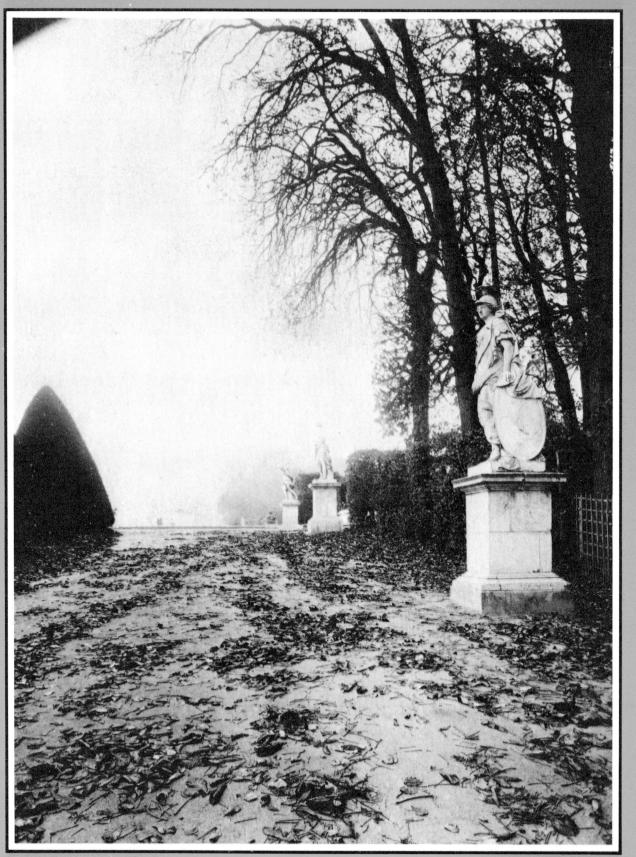

Figure 6

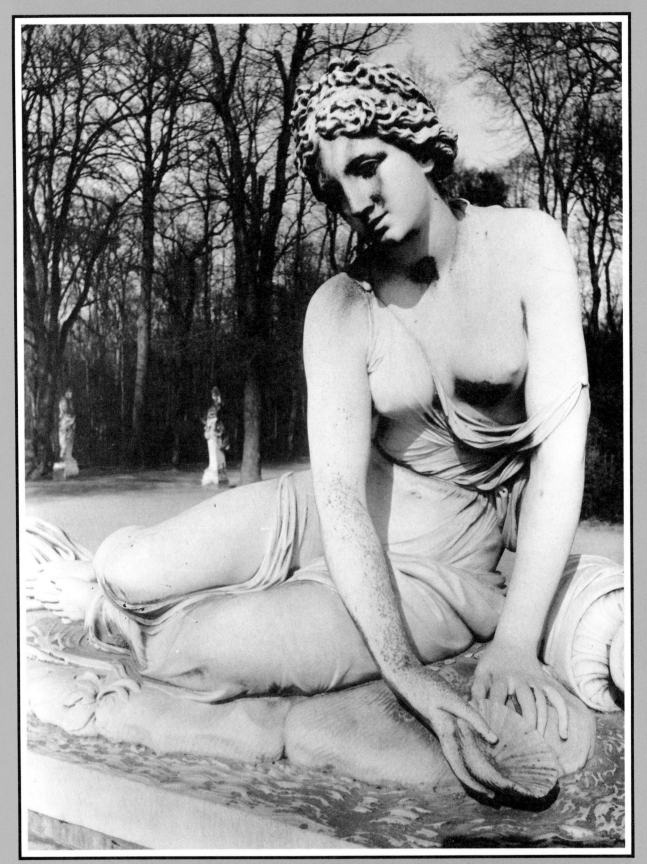

Figure 7

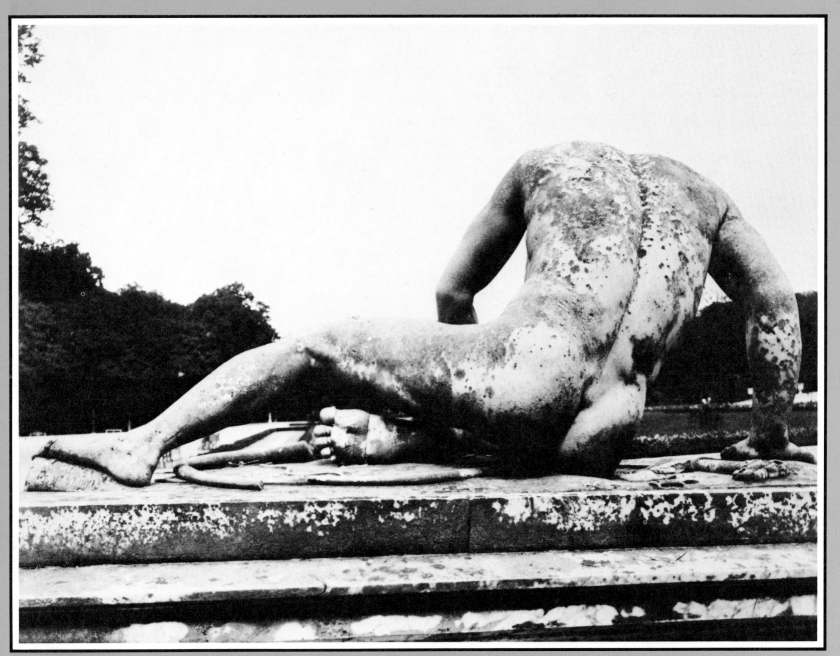

Figure 8

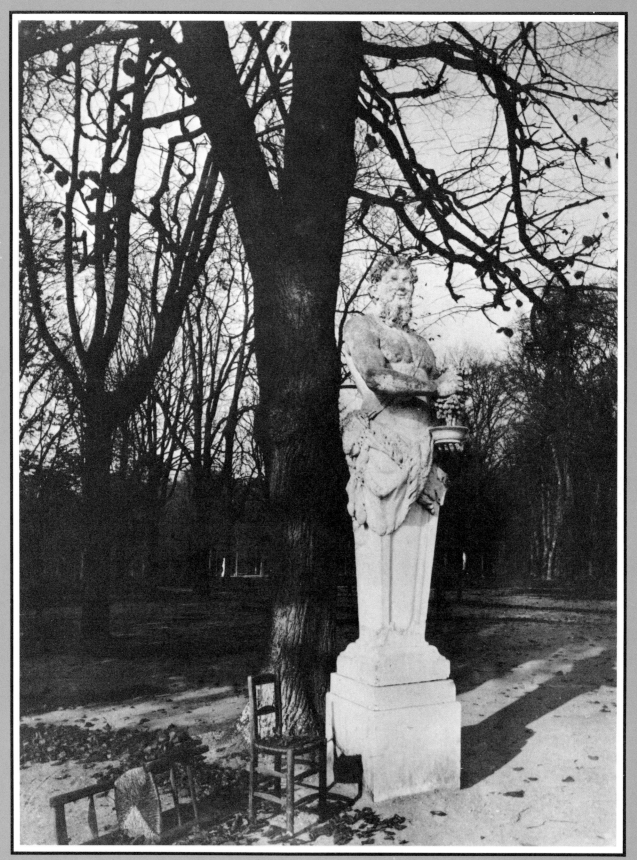

Figure 9

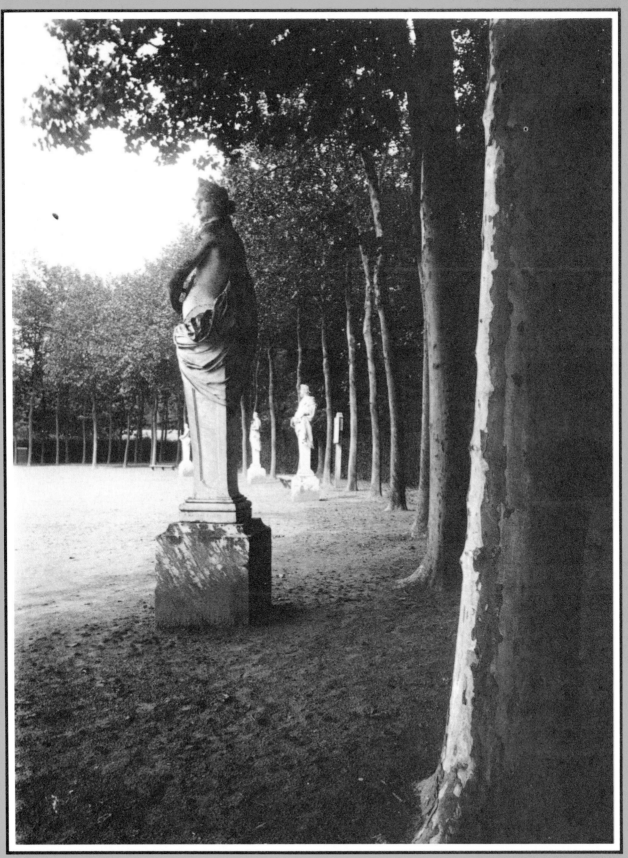

Figure 10

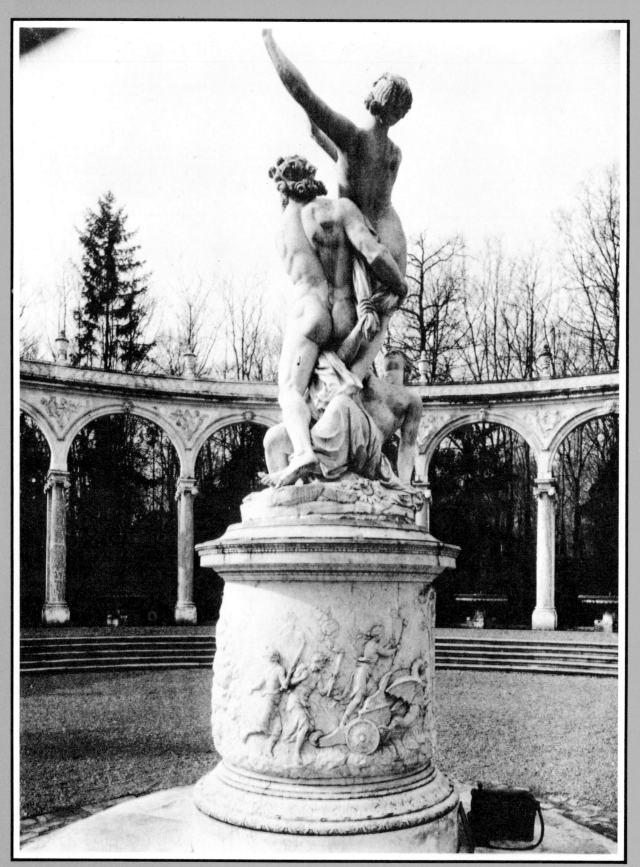

Figure 11

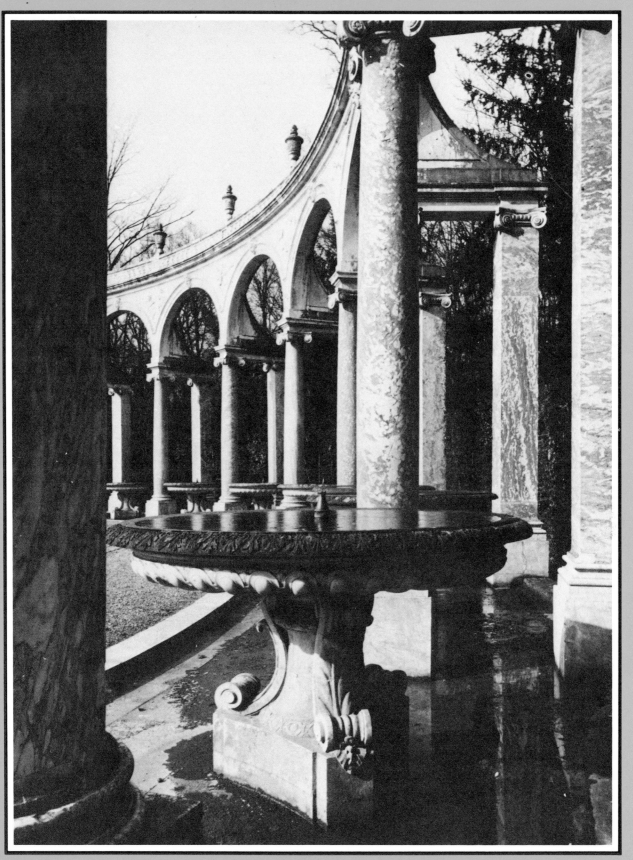

Figure 12

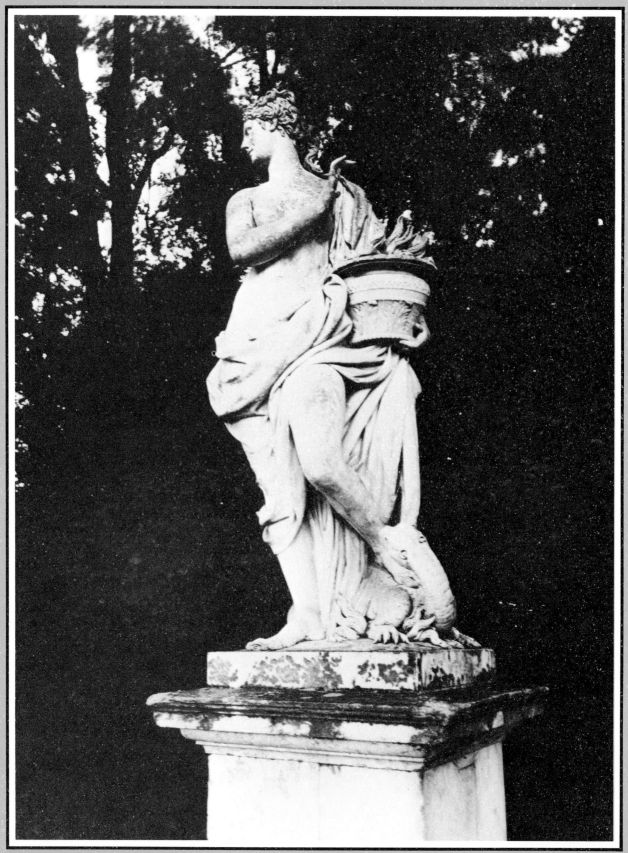

Figure 13

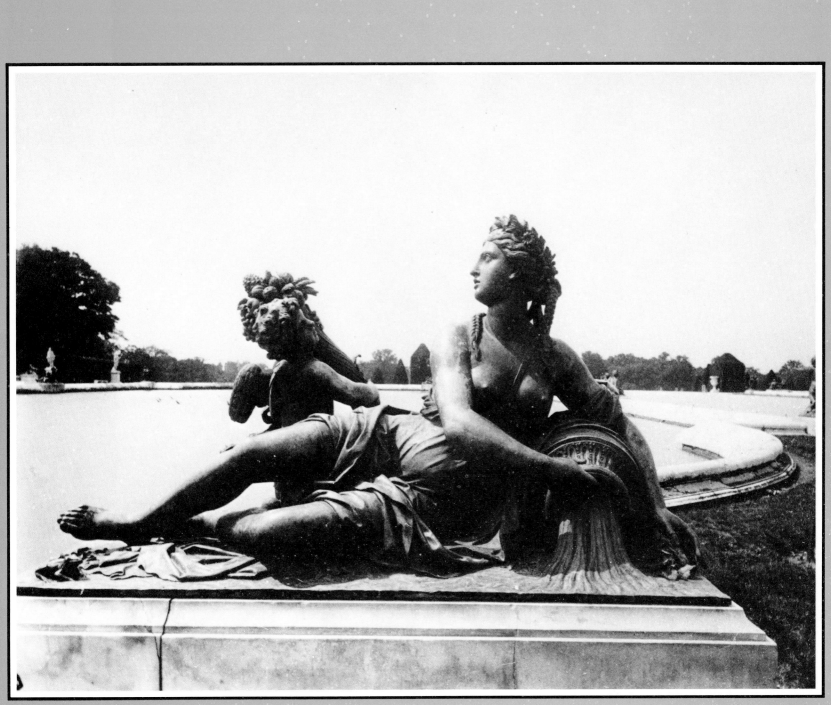

Figure 14

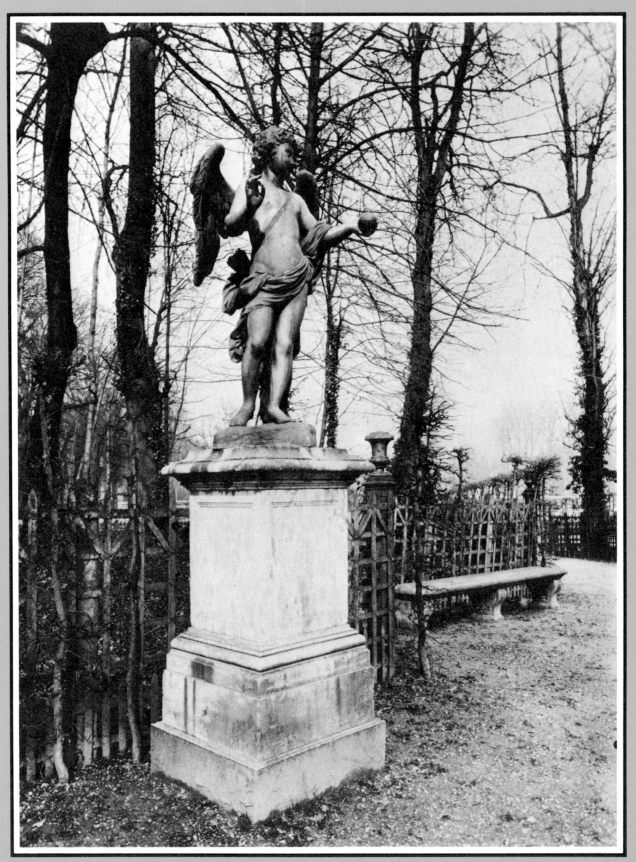

Figure 15

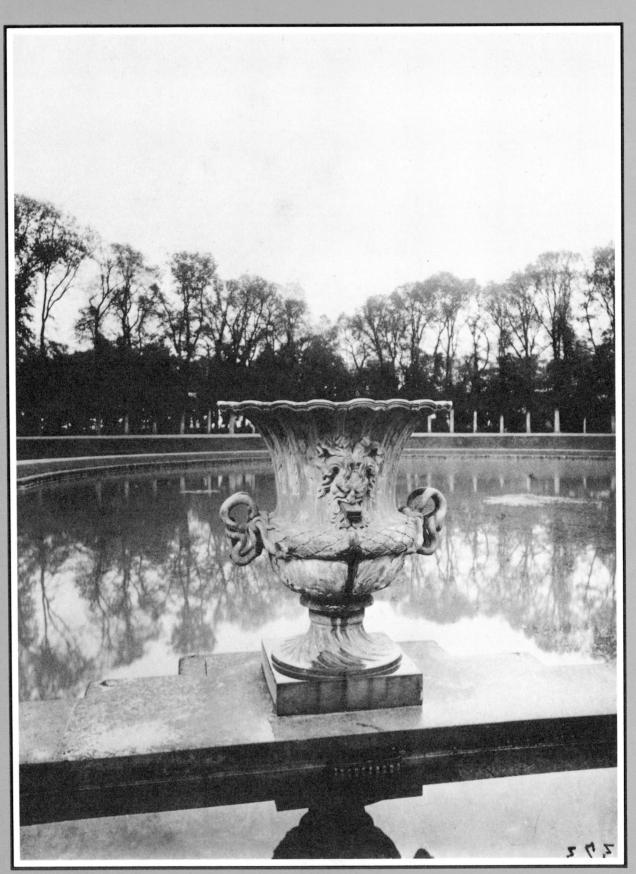

Figure 16

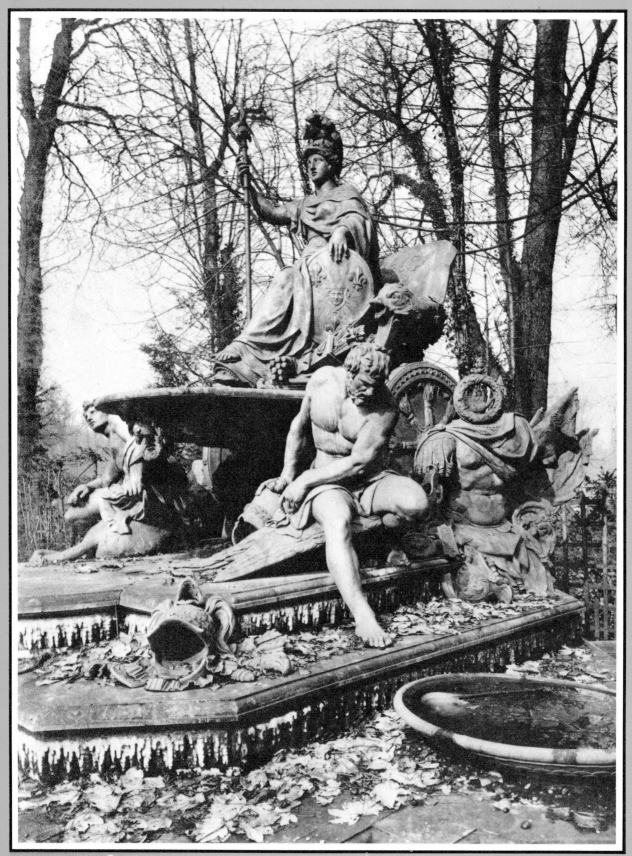

Figure 17

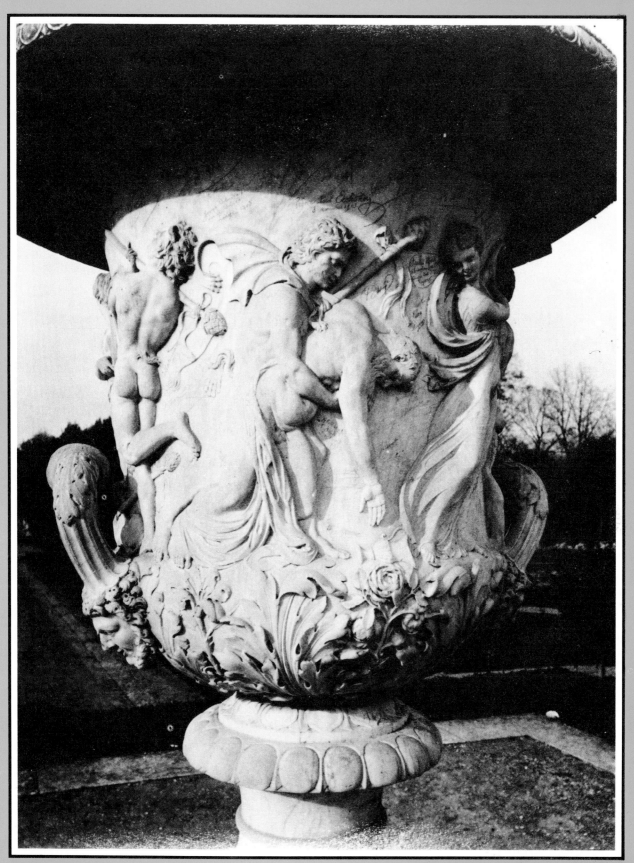

Figure 18

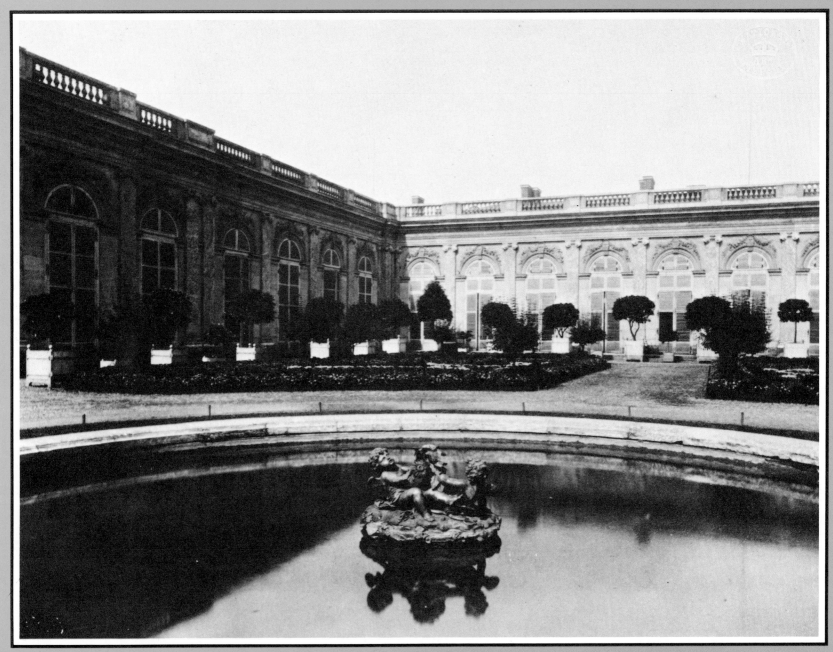

Figure 19

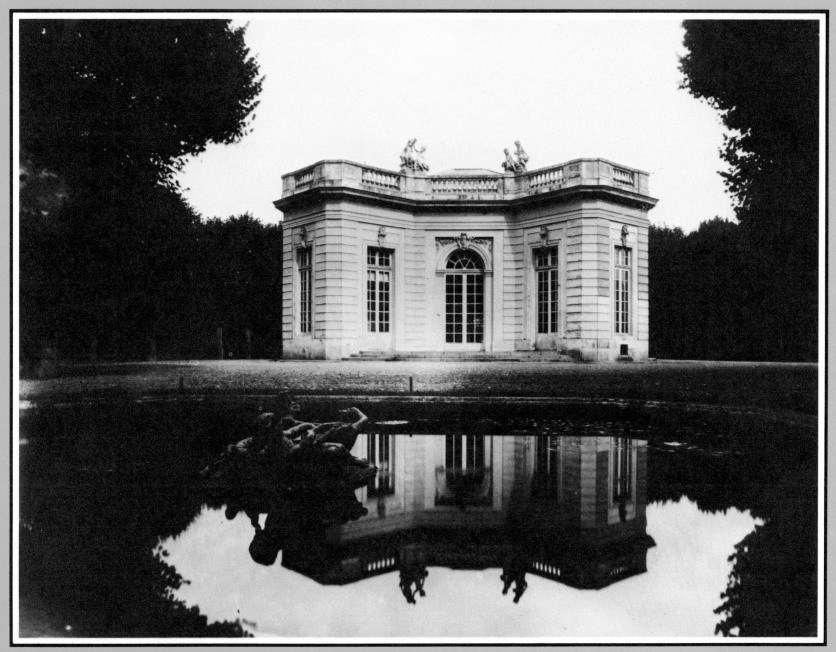

Figure 20

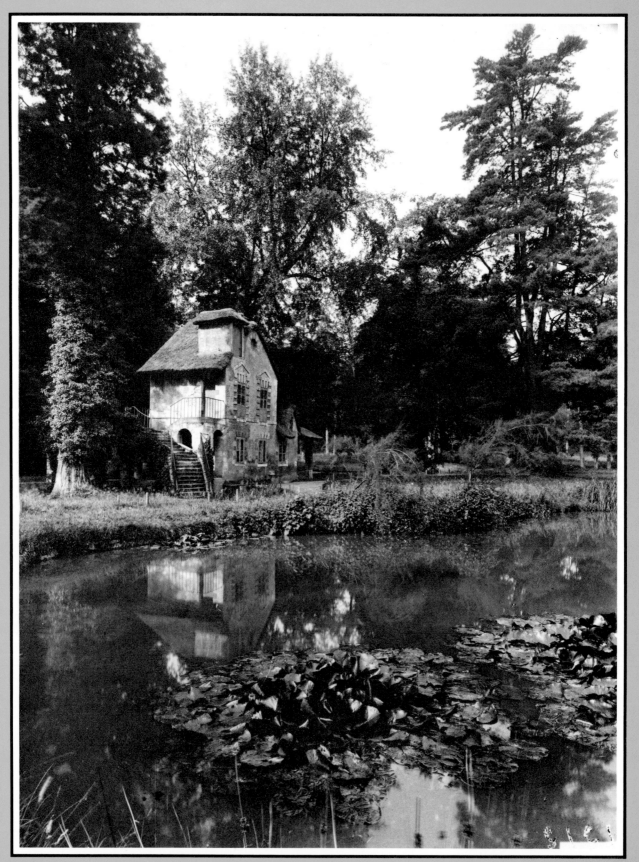

Figure 21

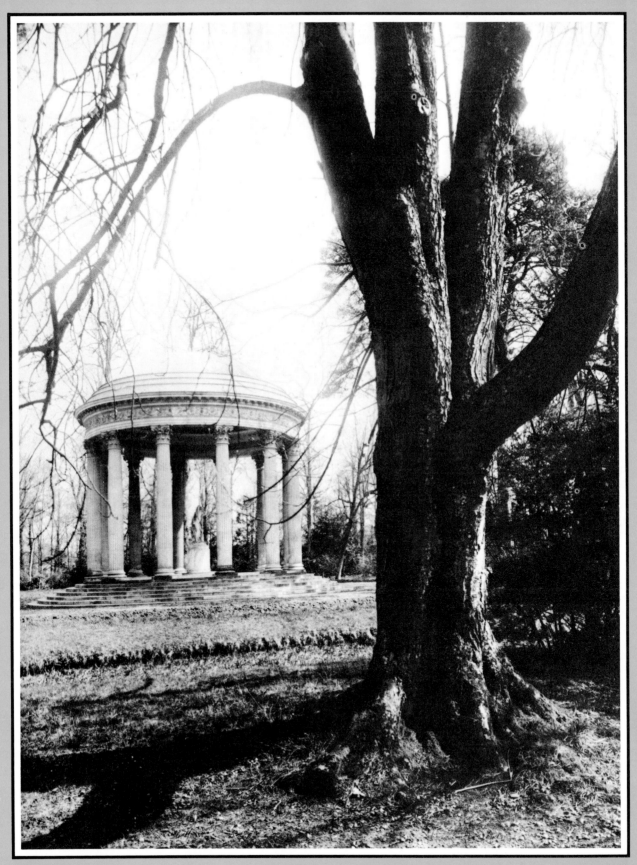

Figure 22

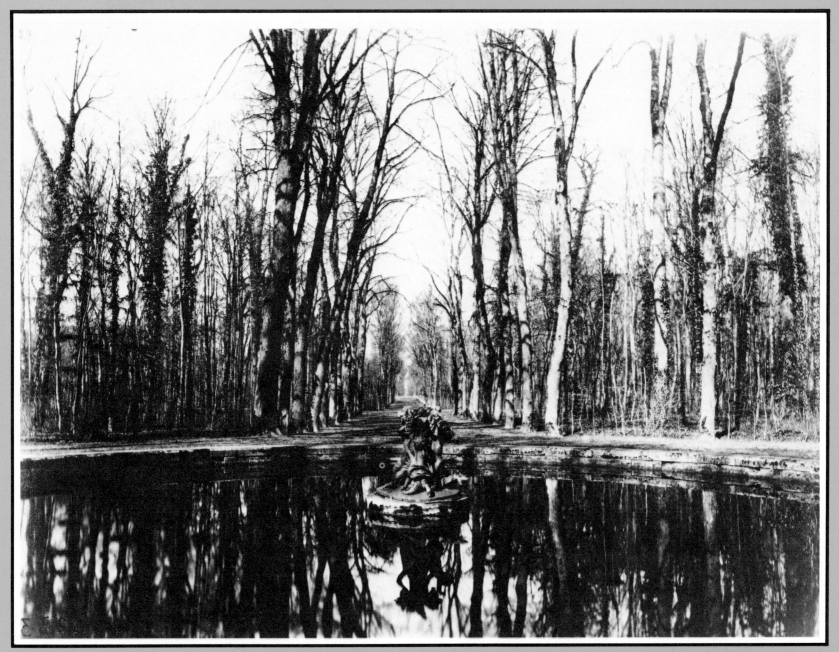

Figure 23

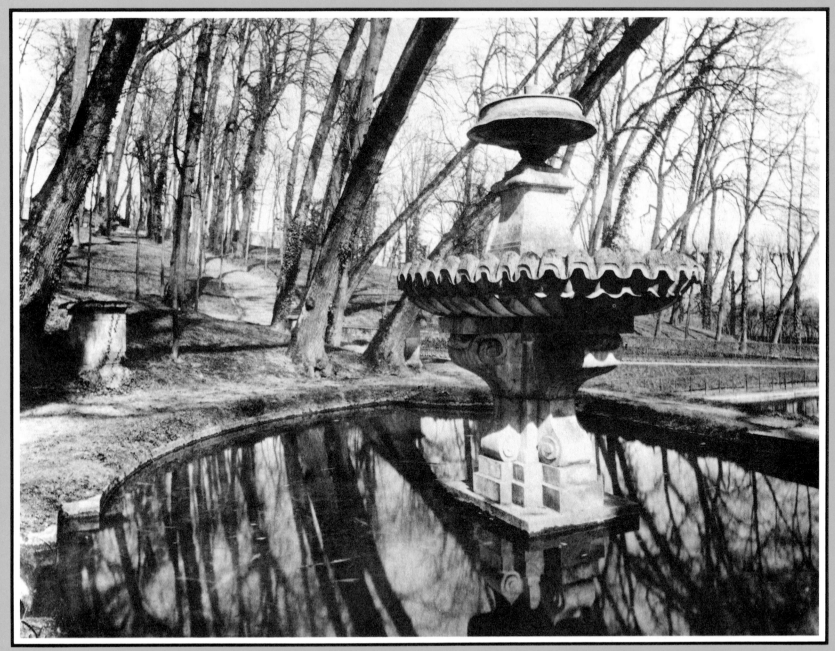

Figure 24

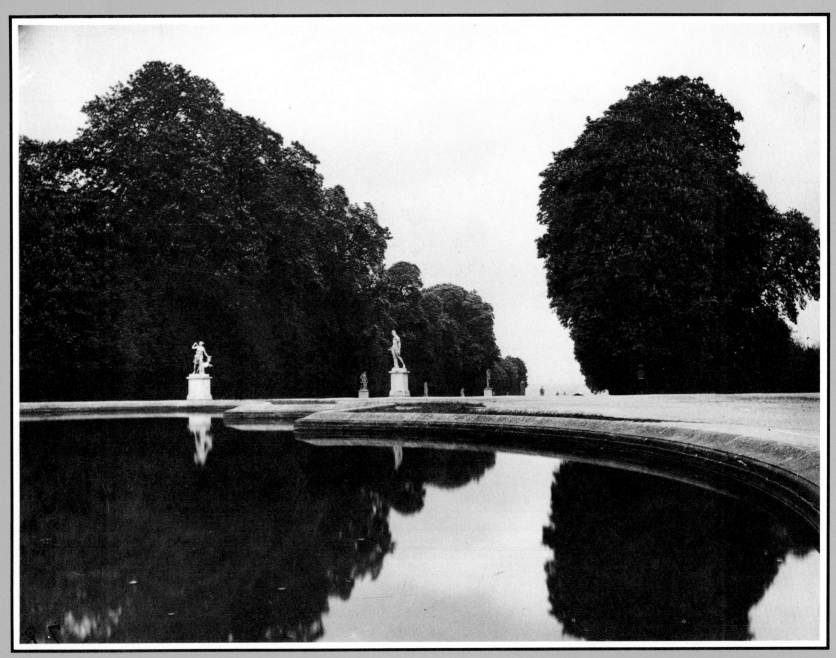

Figure 25

Figure 26

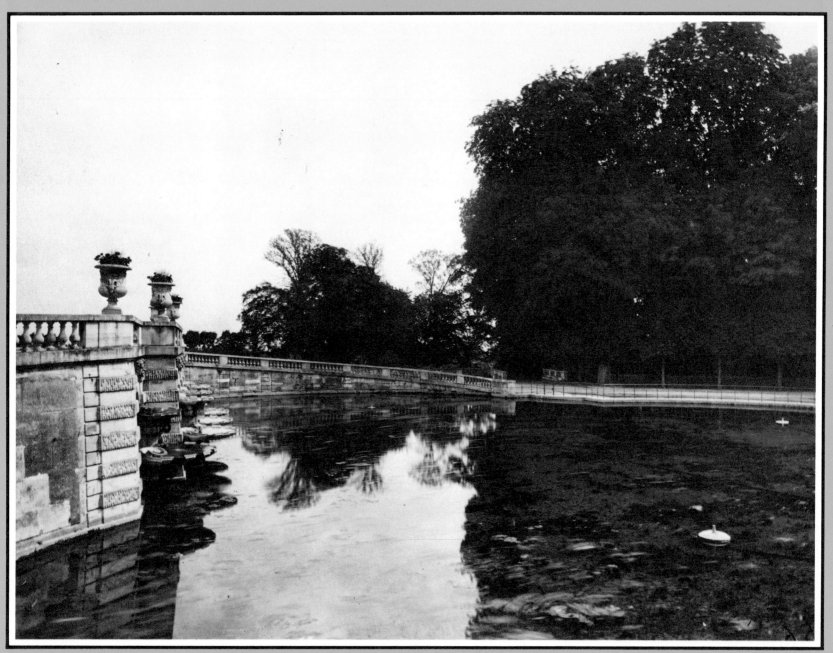

Figure 27

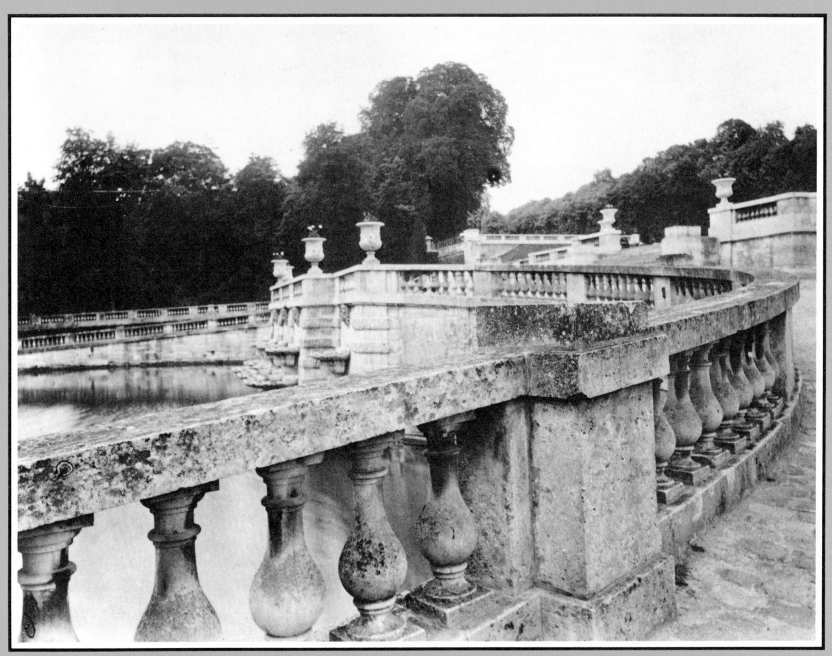

Figure 28

Figure 29

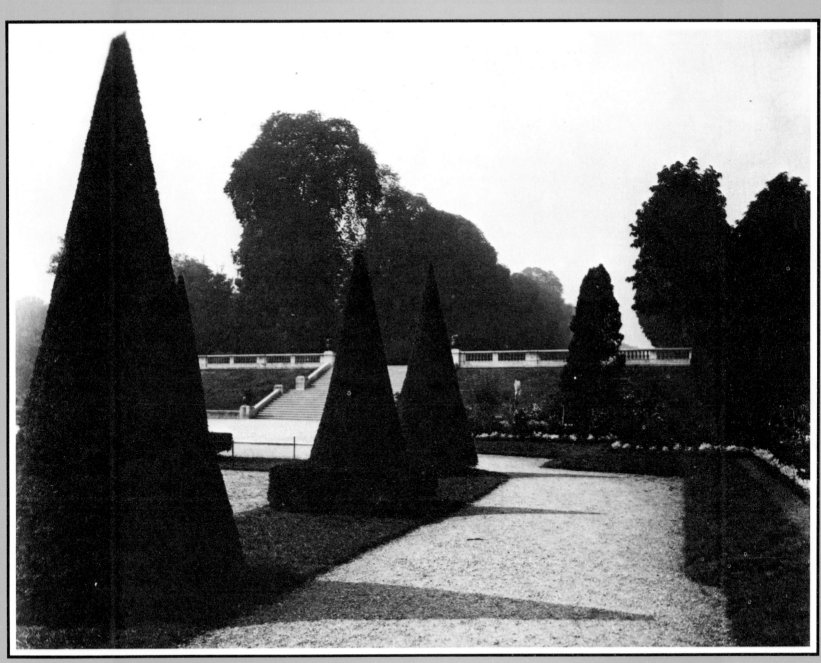

Figure 30

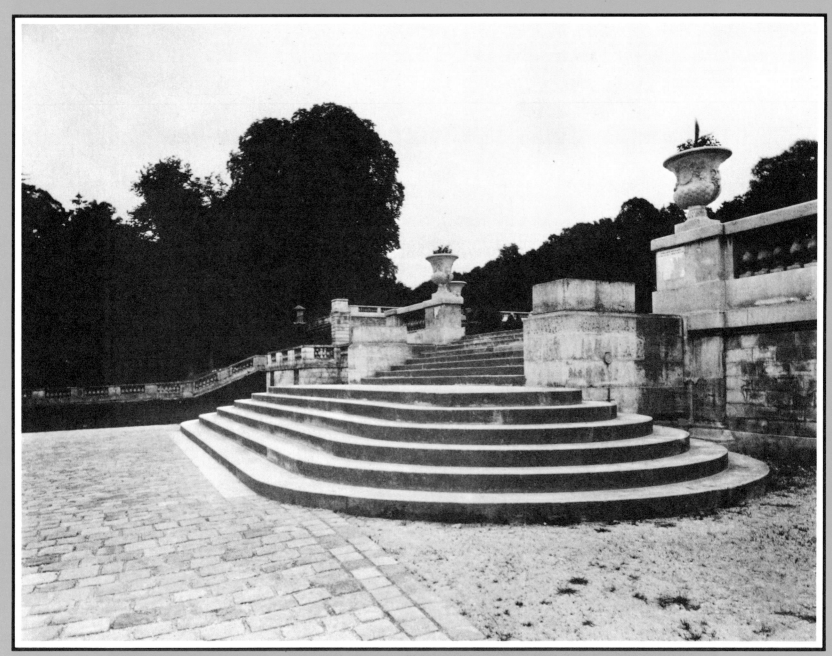

Figure 31

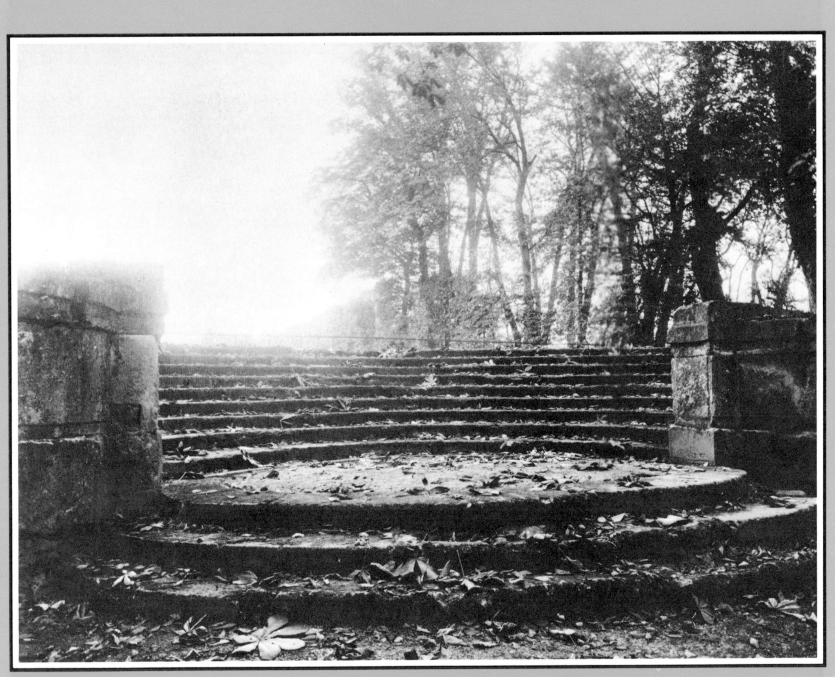

Figure 32

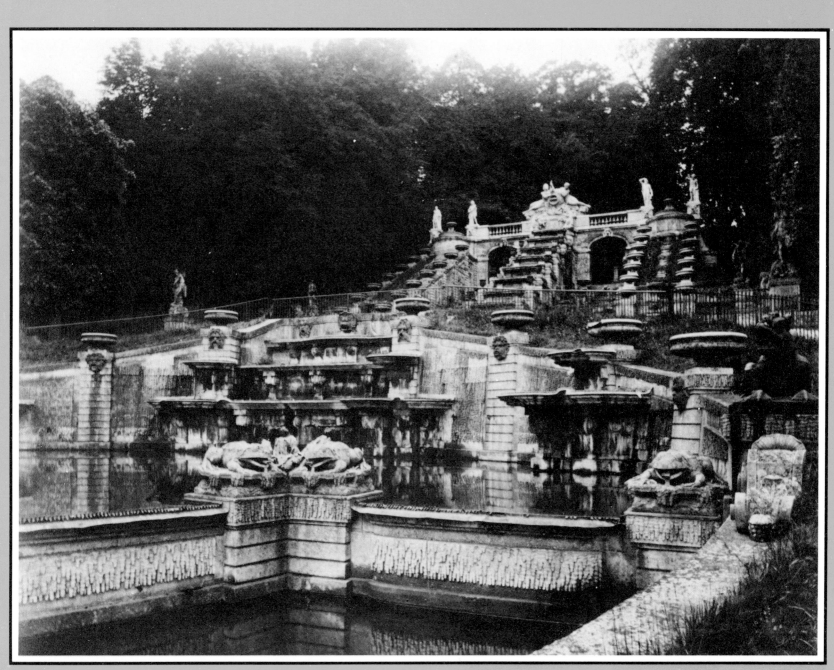

Figure 33

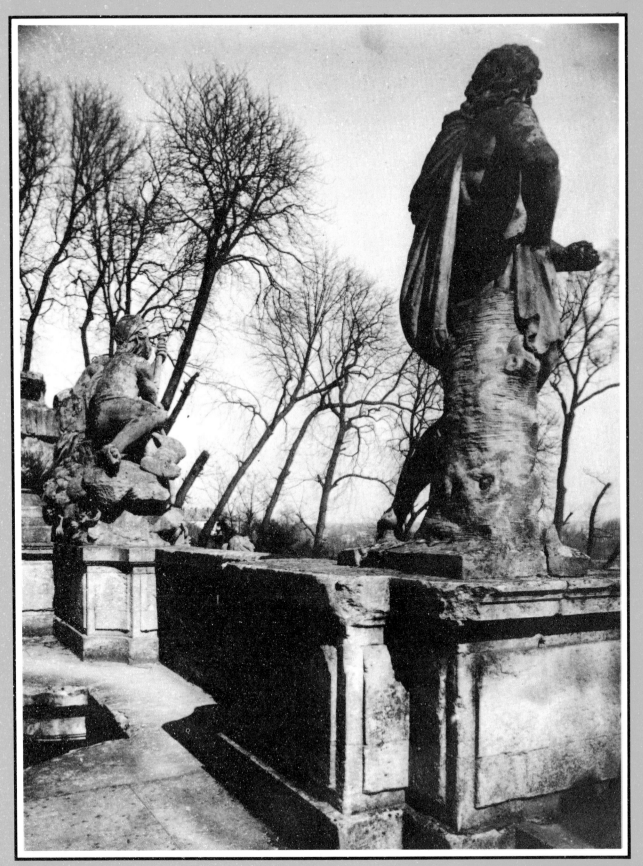

Figure 34

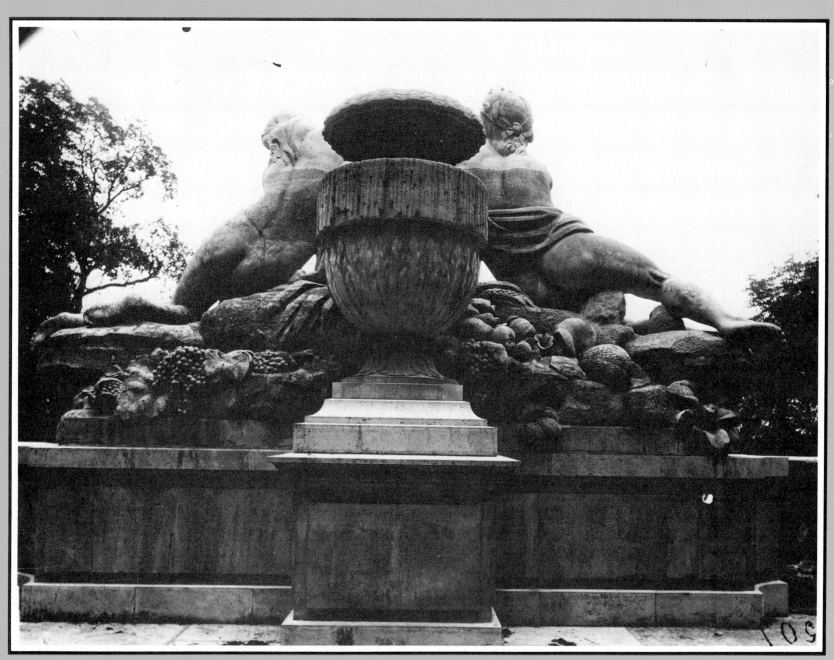

Figure 35

Figure 36

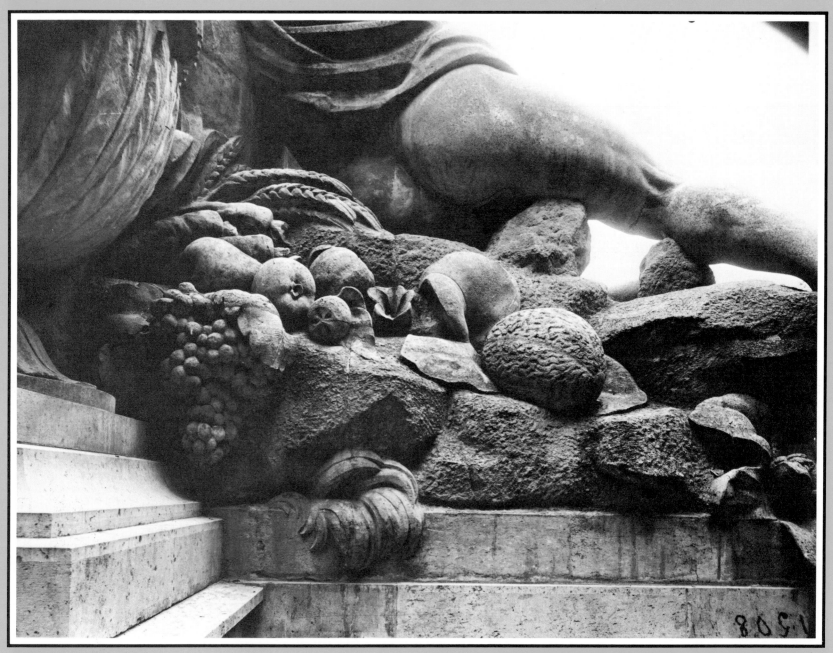

Figure 37

Figure 38

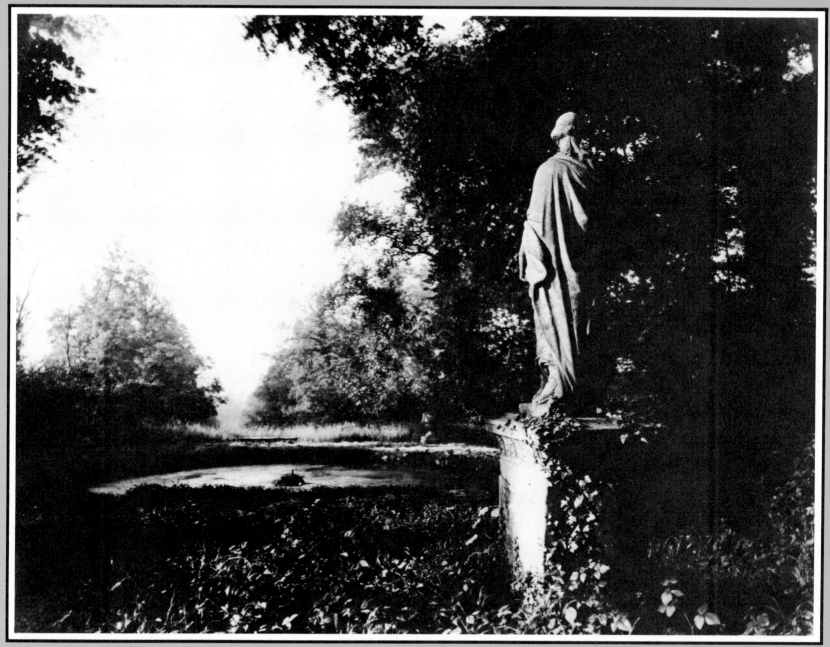

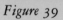

Figure 39

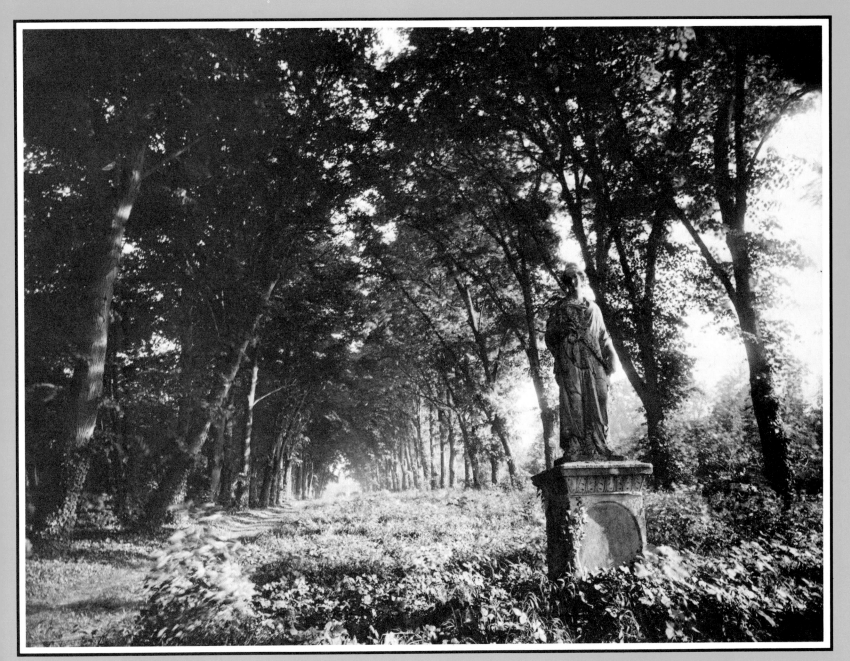

Figure 40

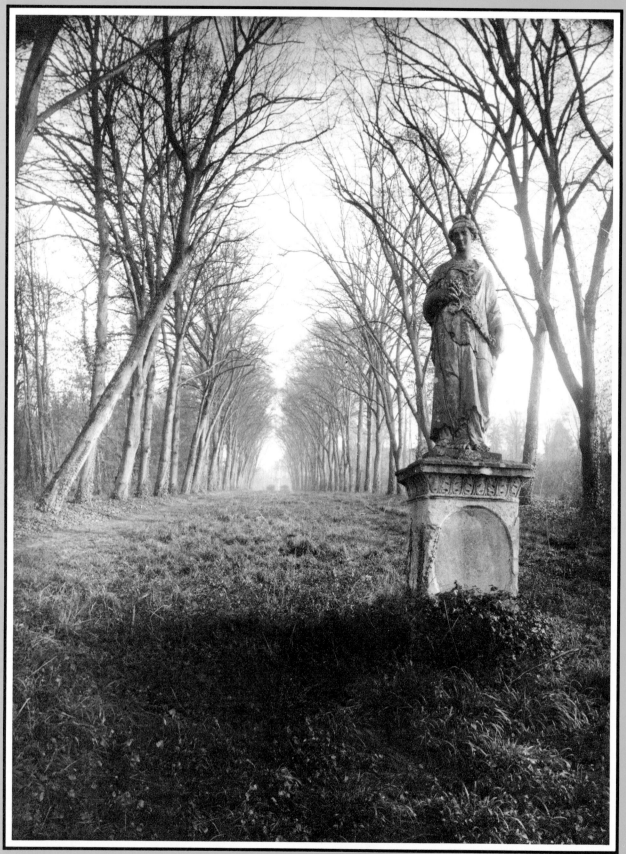

Figure 41

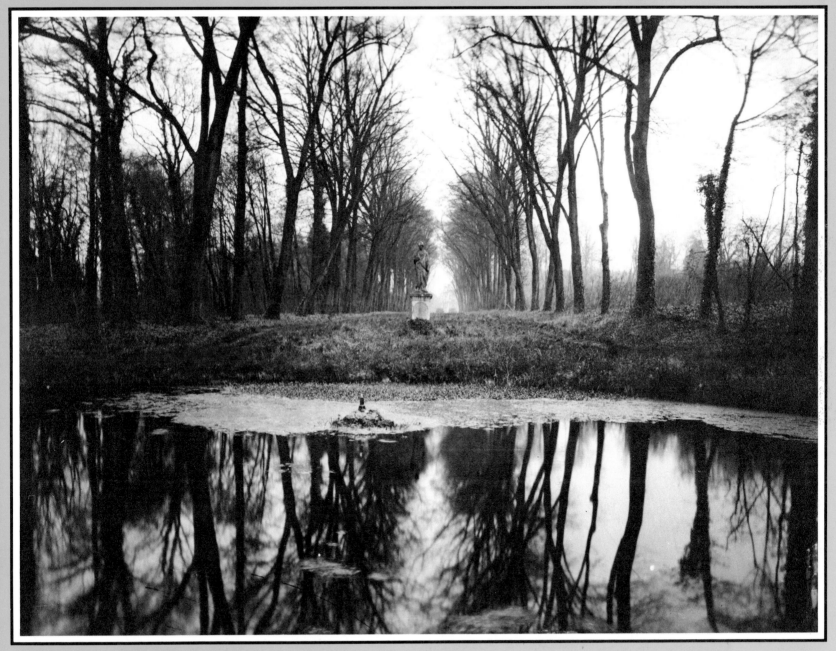

Figure 42

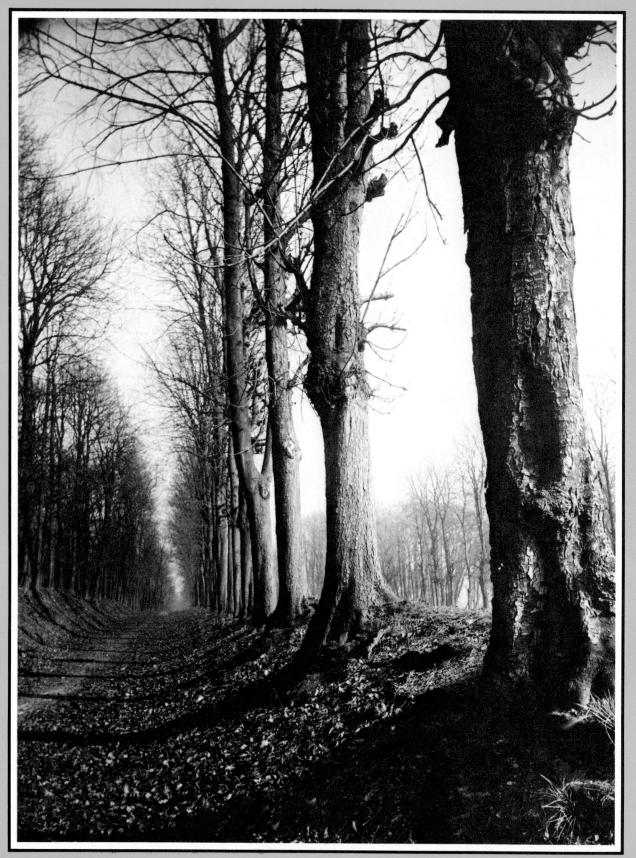

Figure 43

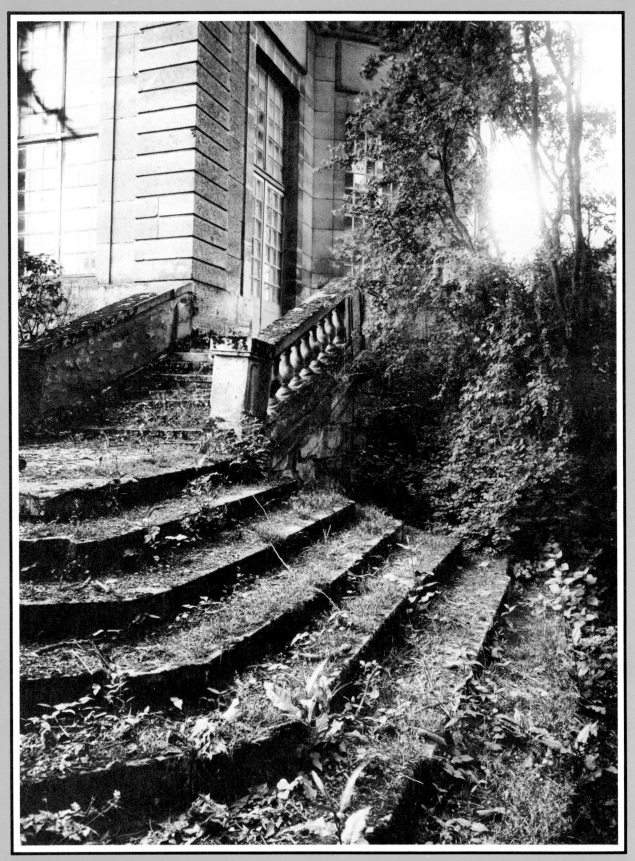

Figure 44

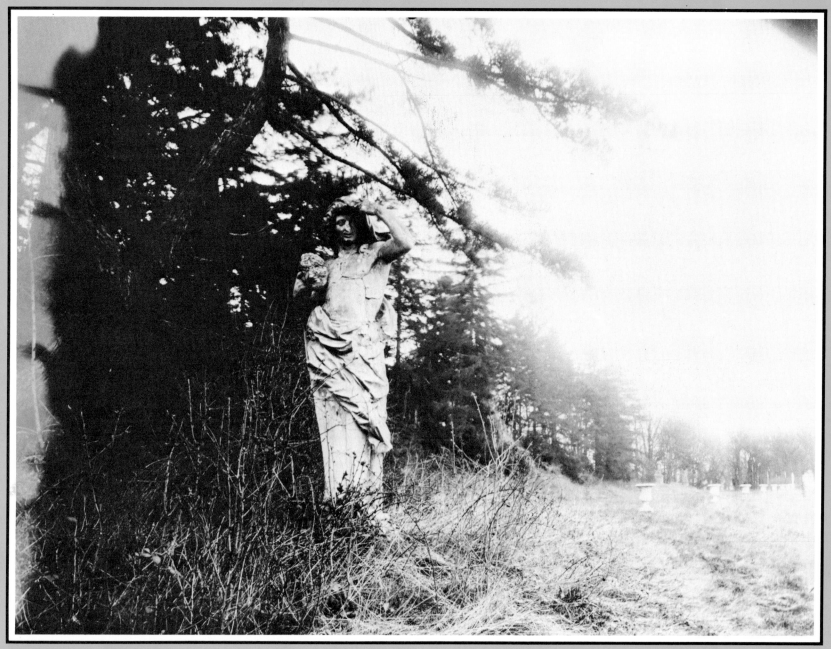

Figure 45

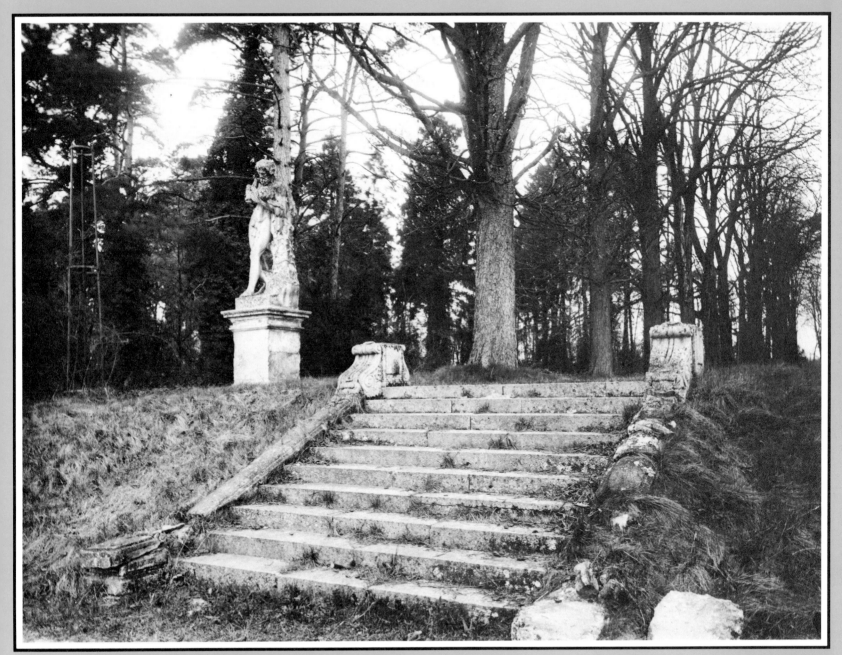

Figure 46

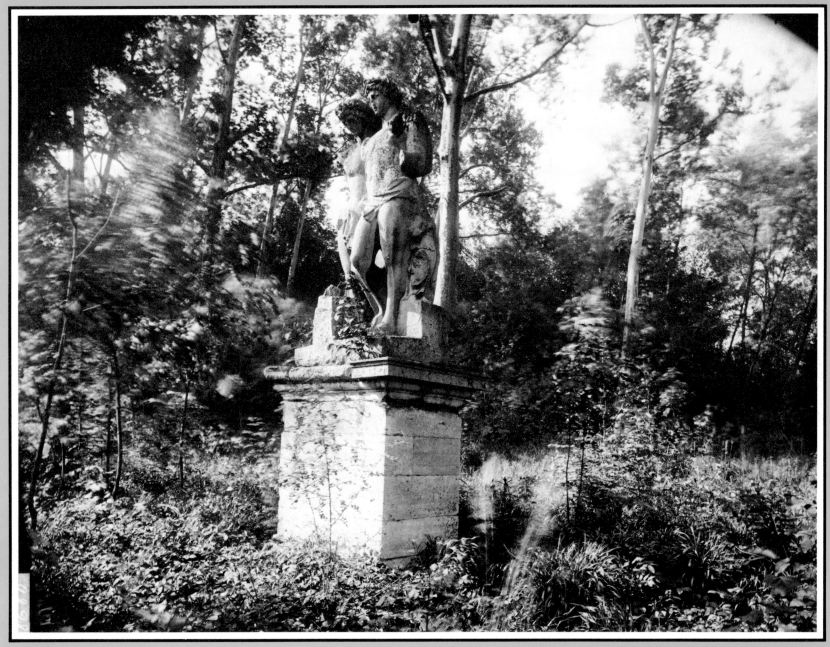

Figure 47

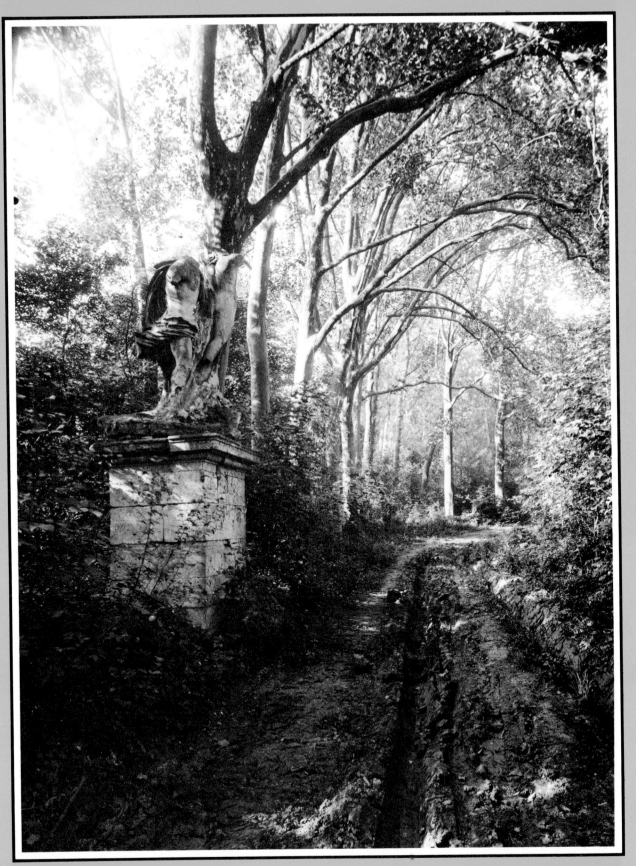

Figure 48

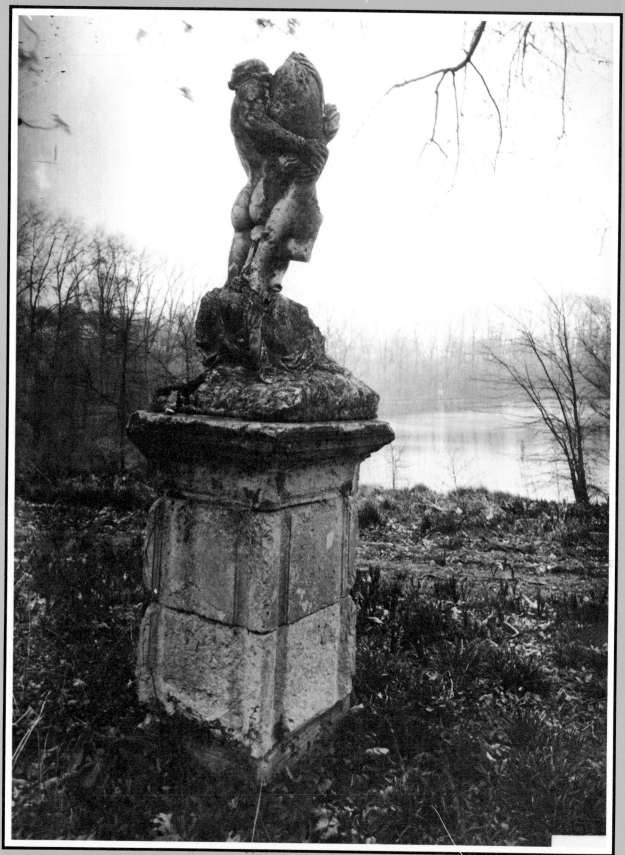

Figure 49

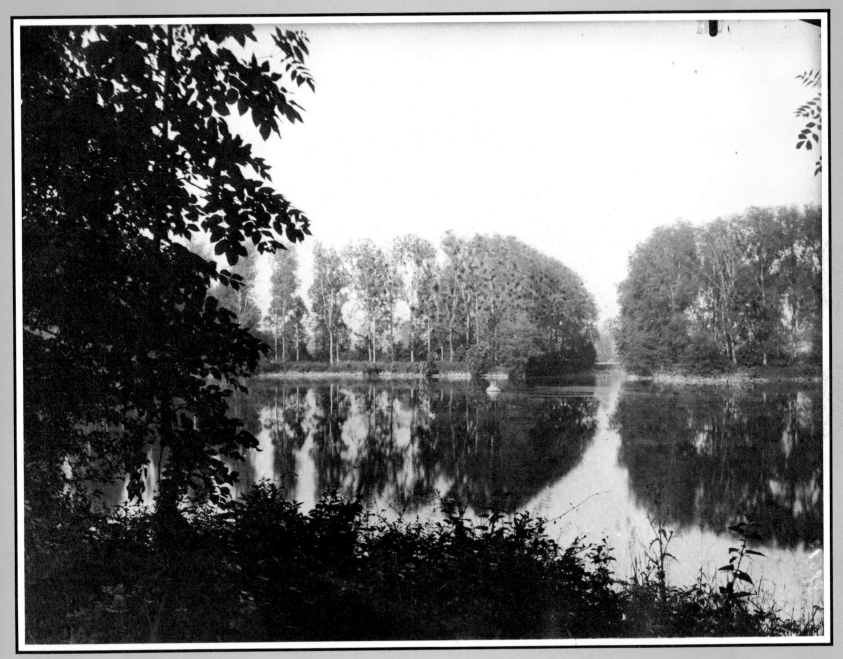

Figure 50

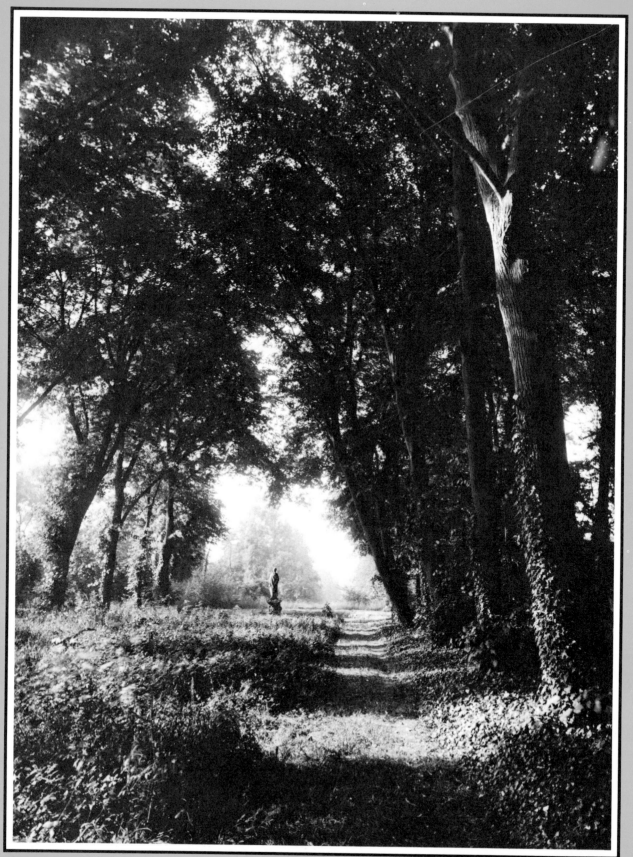

Figure 51

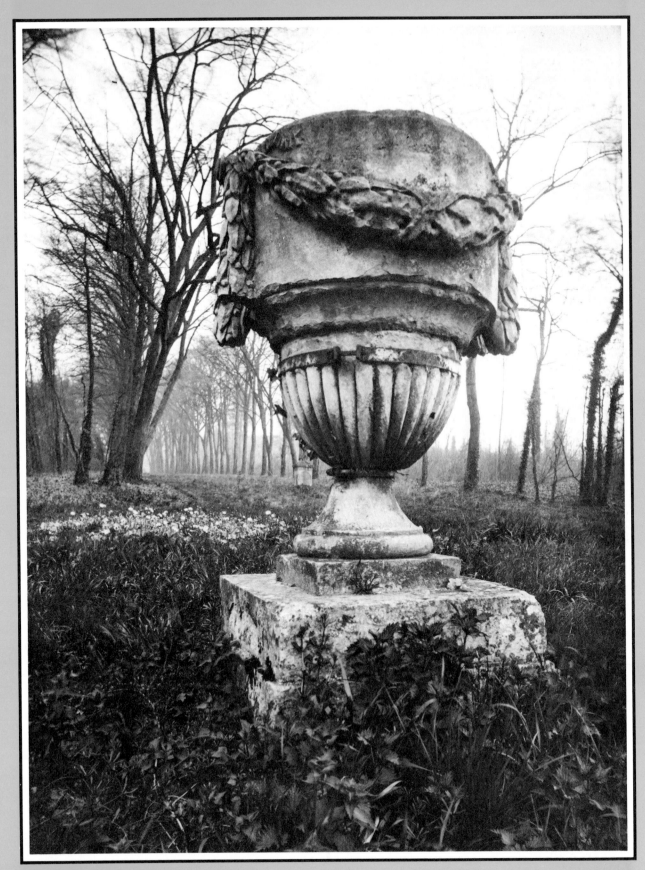

Figure 52

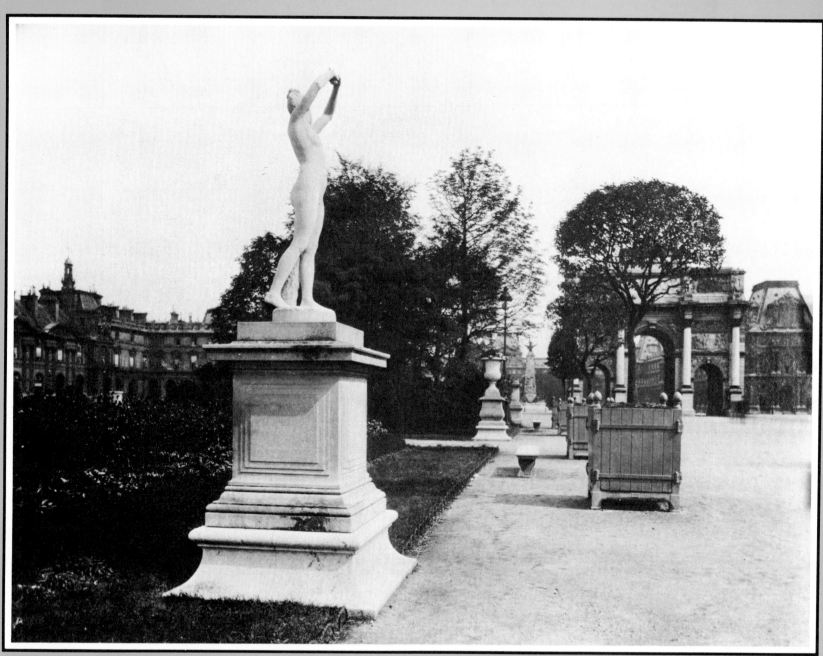

Figure 53

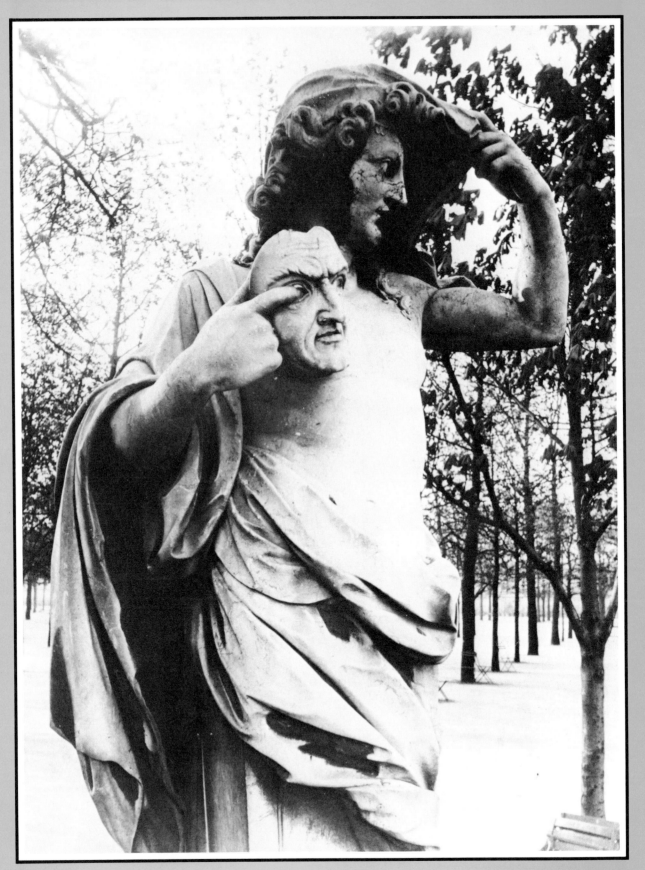

Figure 54

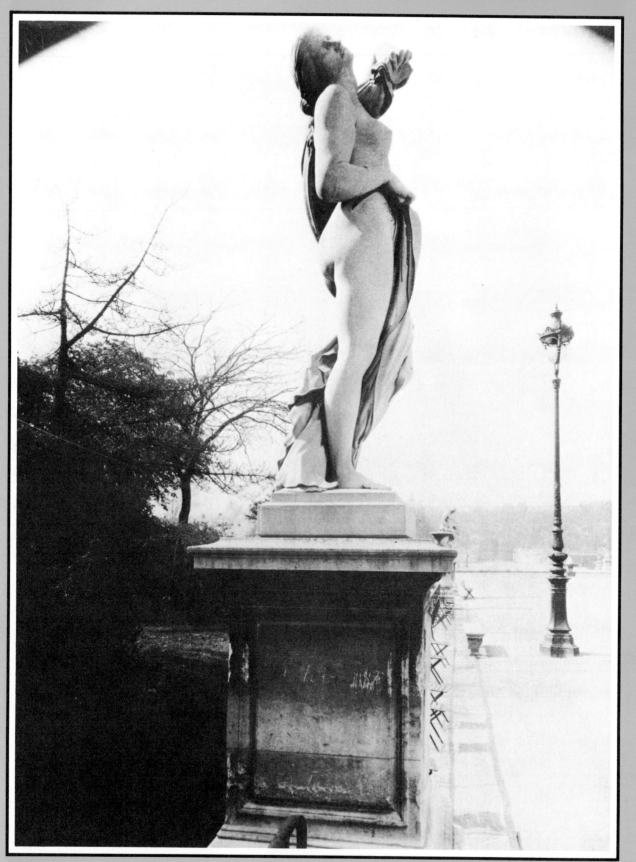

Figure 55

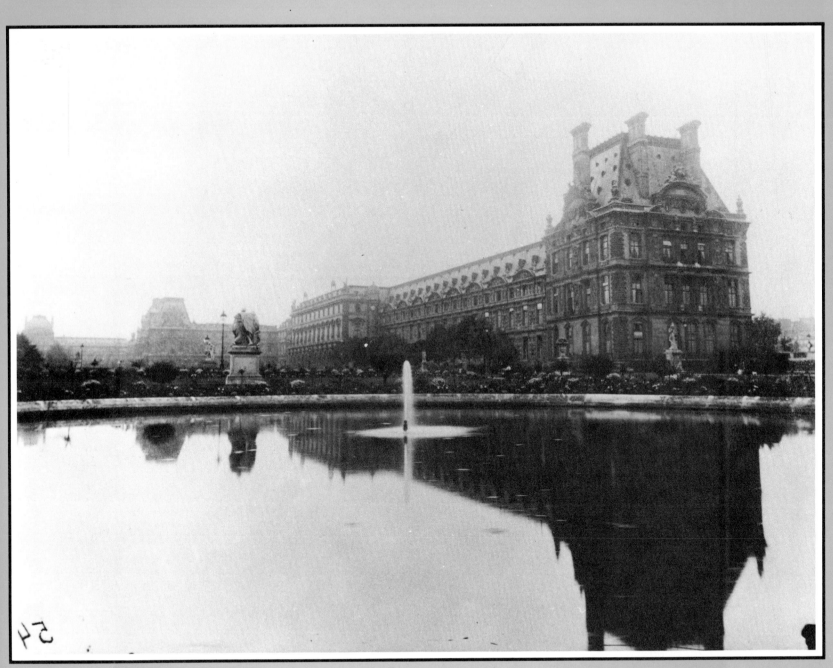

Figure 56

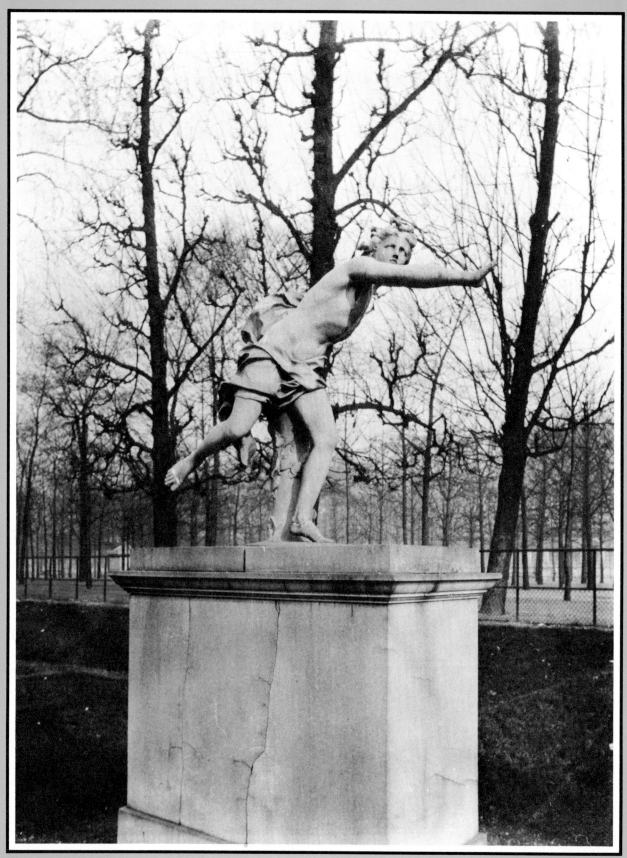

Figure 57

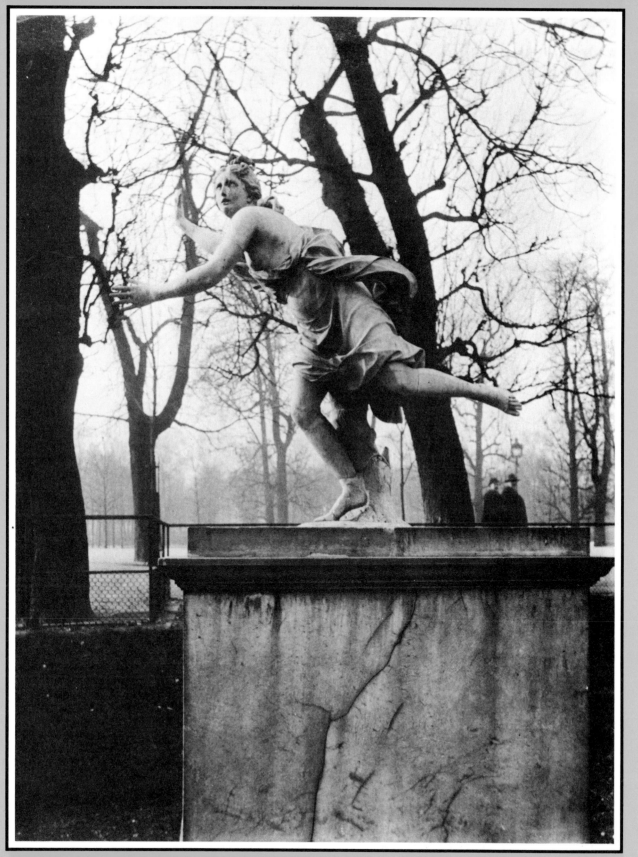

Figure 58

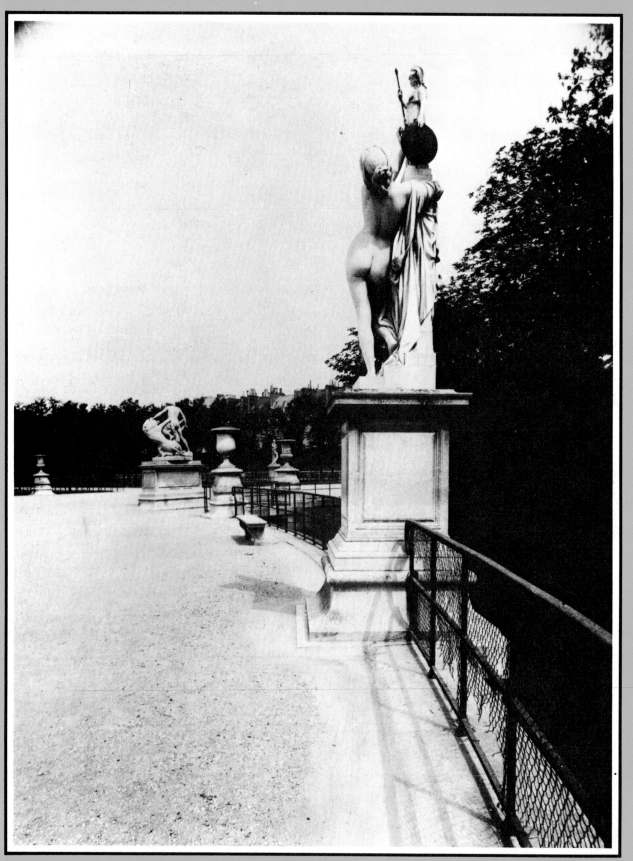

Figure 59

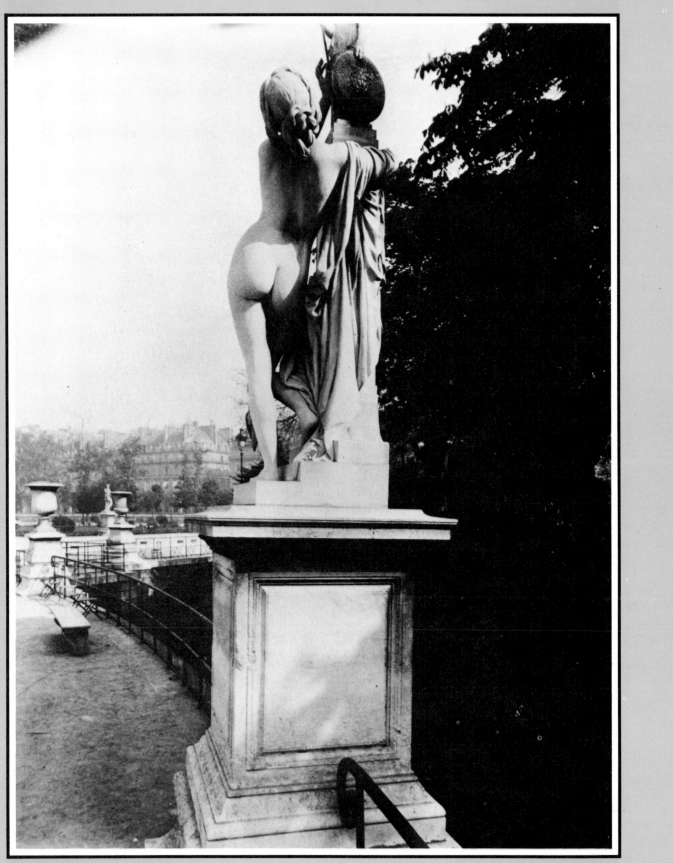

Figure 60

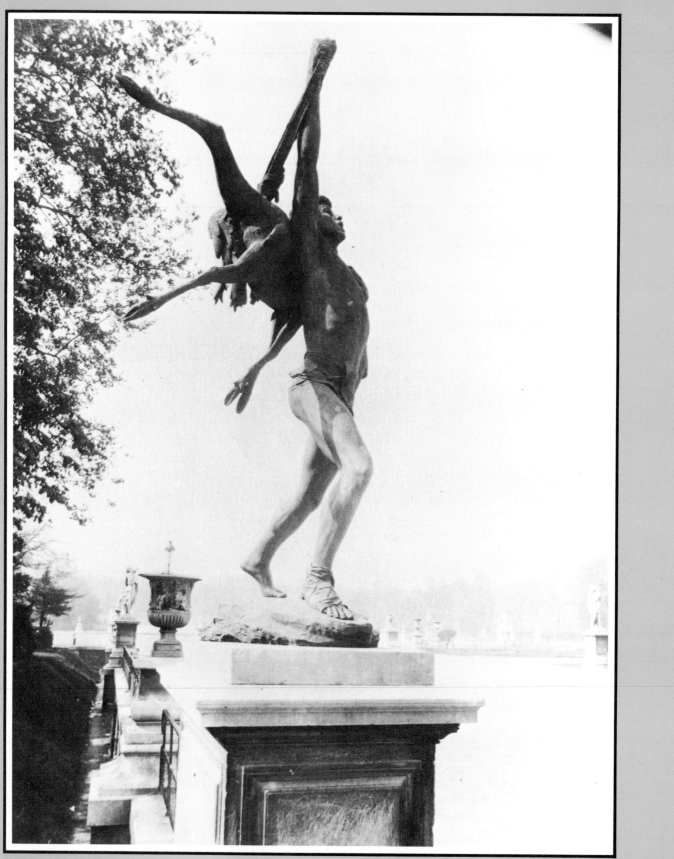

Figure 61

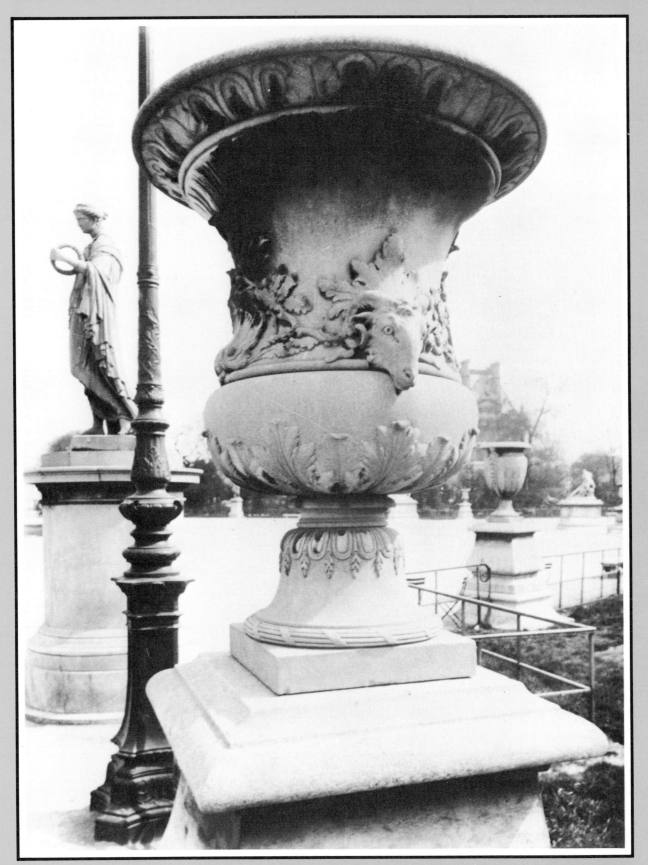

Figure 62

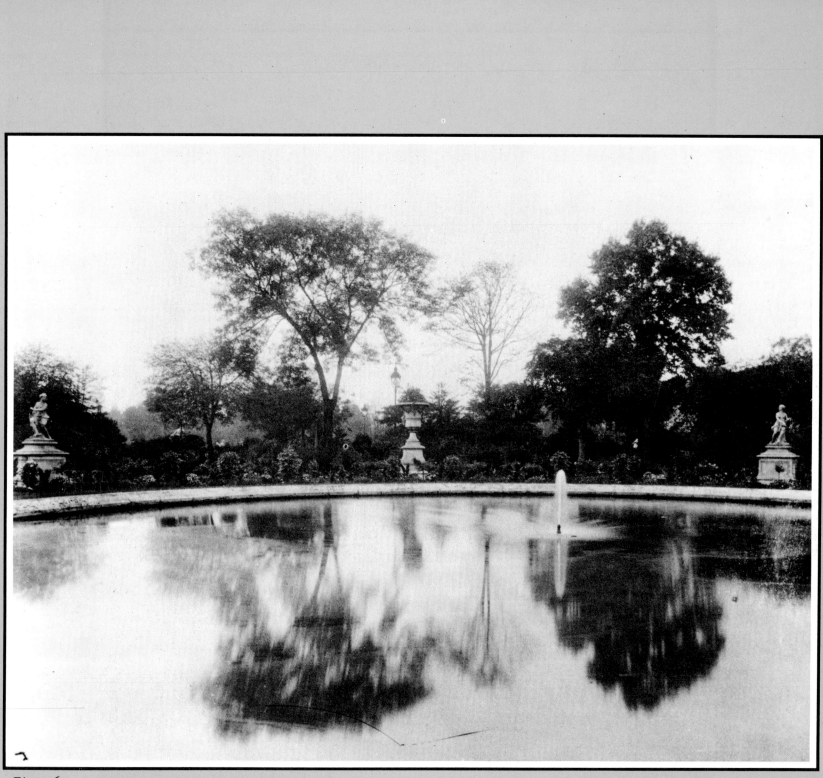

Figure 63

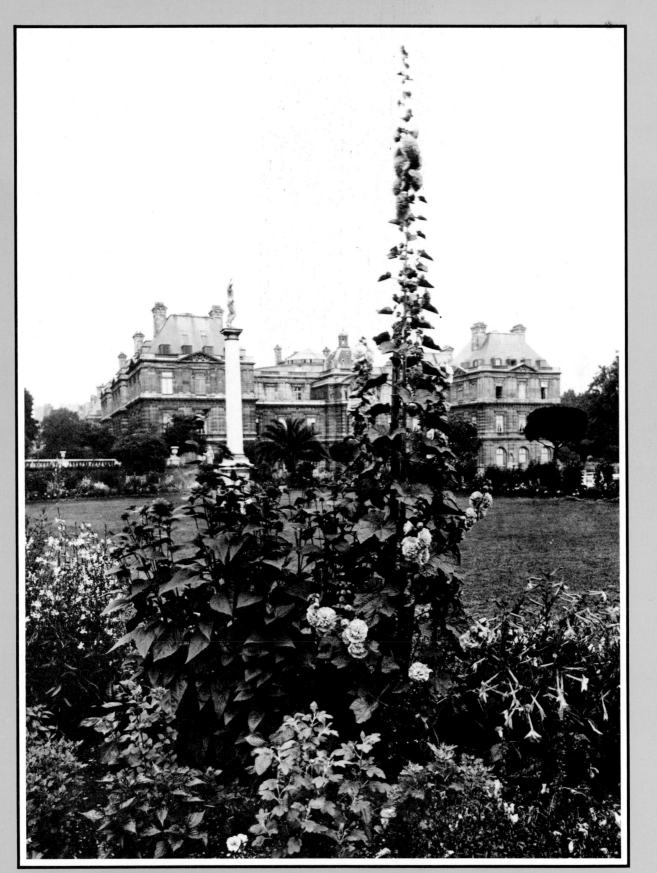

Figure 64

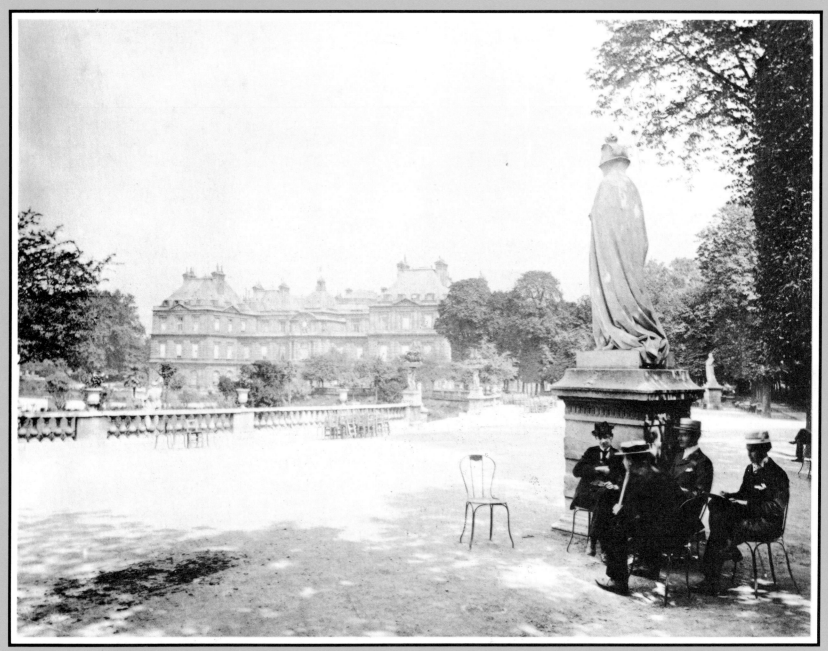

Figure 65

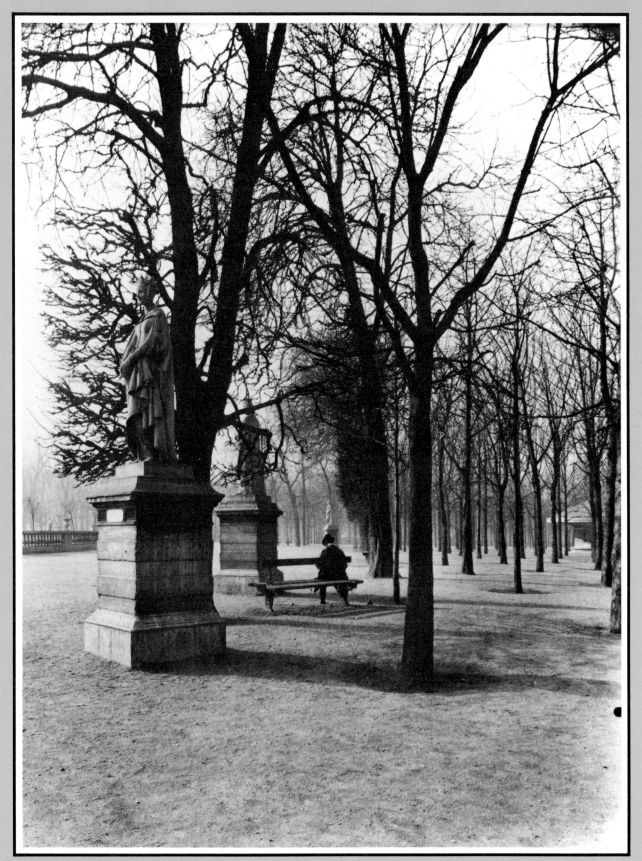

Figure 66

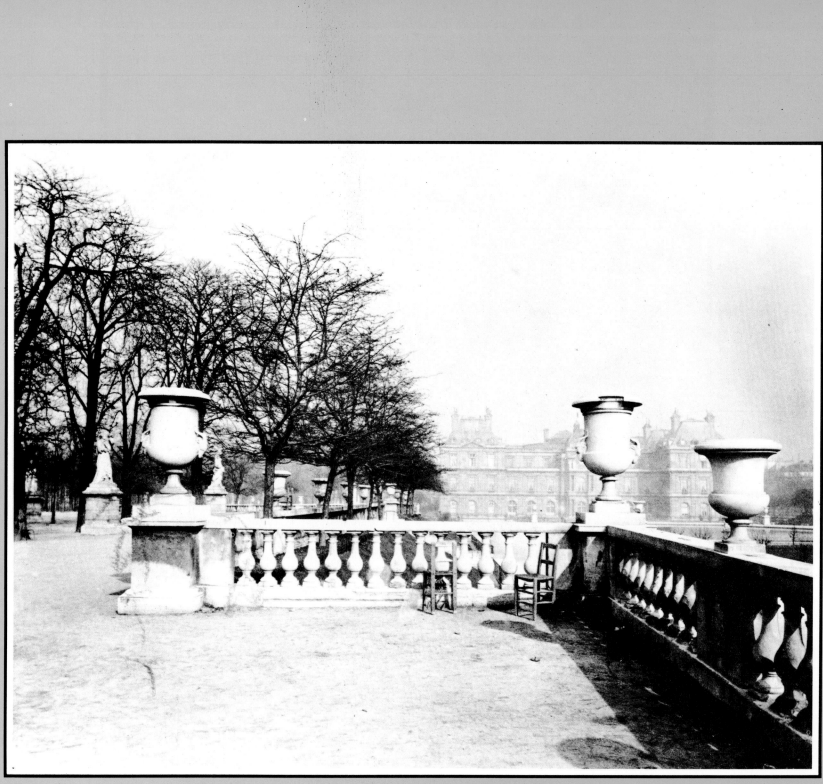

Figure 67

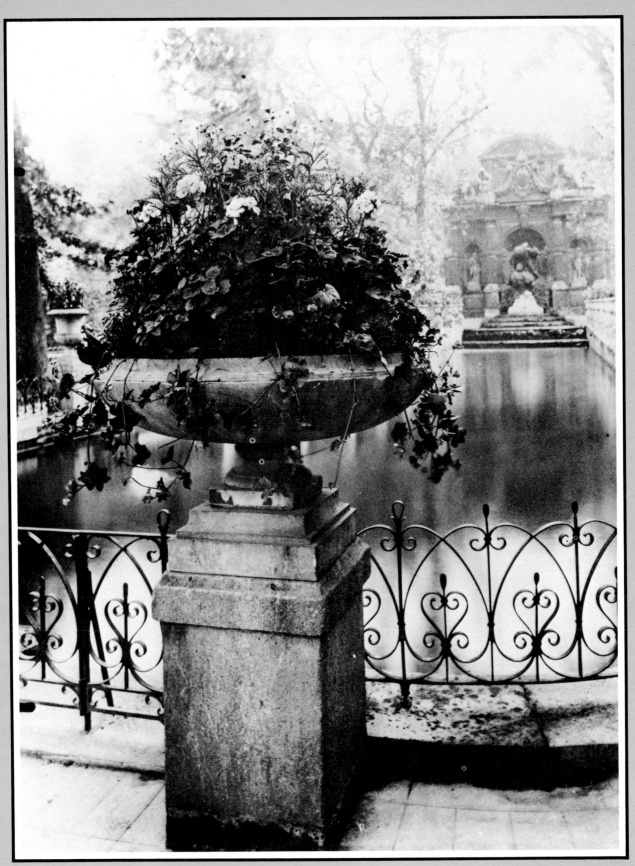

Figure 68

Figure 69

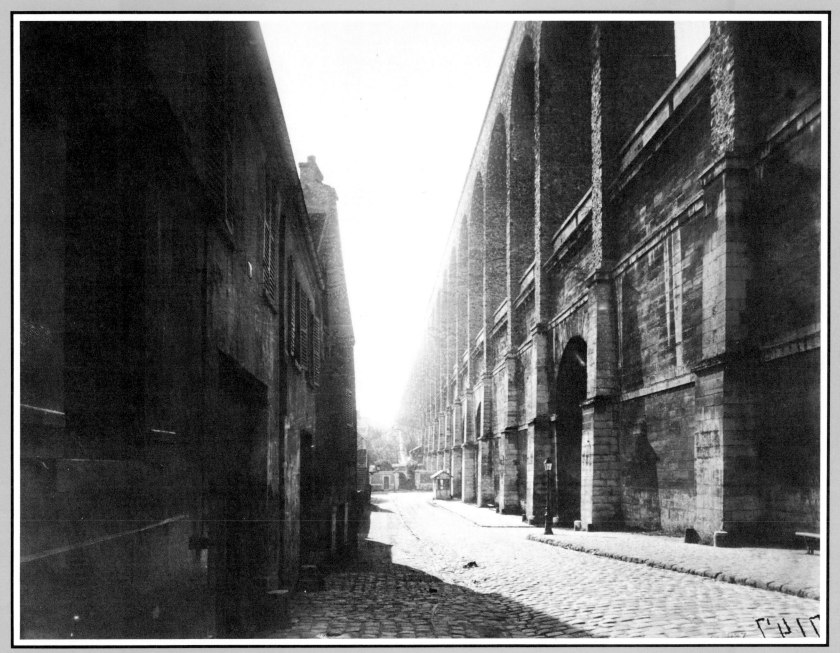

Figure 70

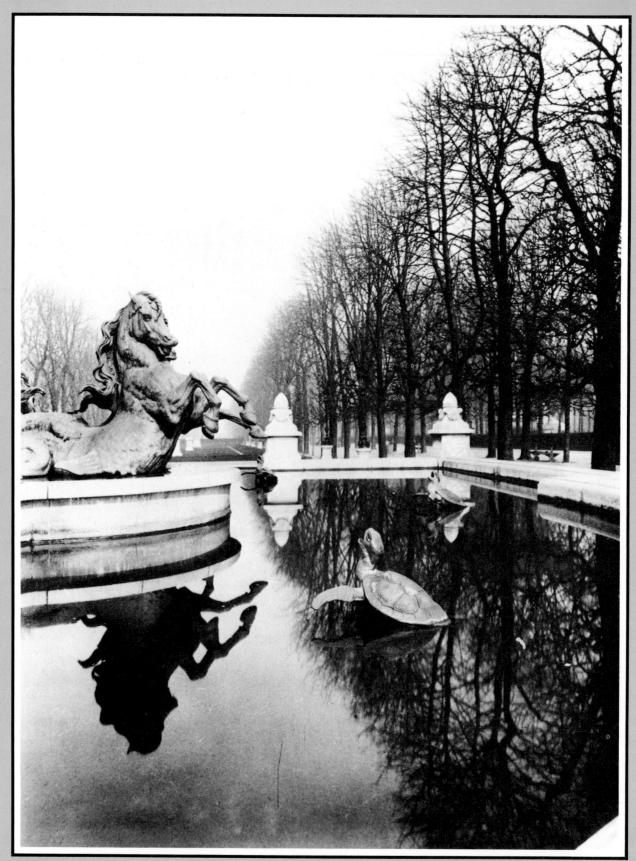

Figure 71

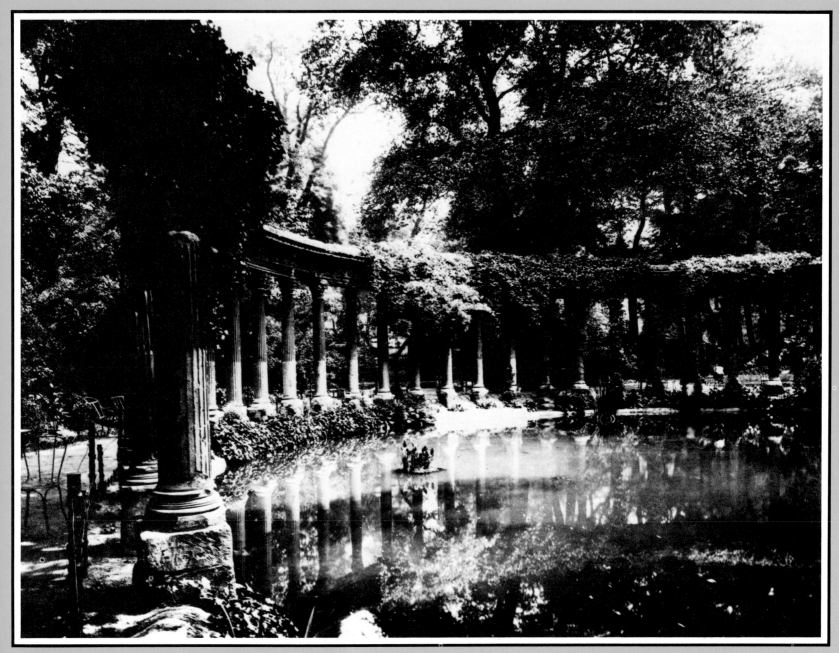

Figure 72

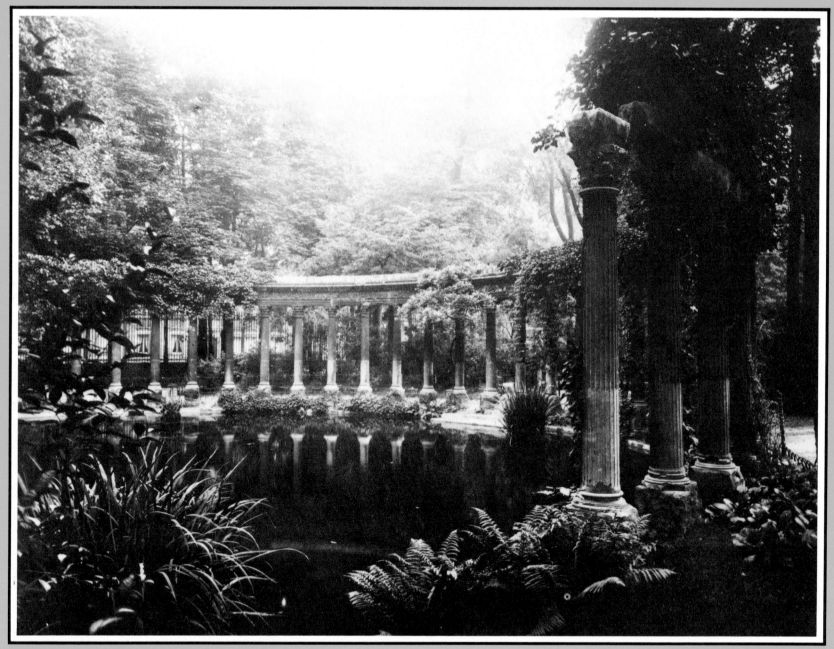

Figure 73

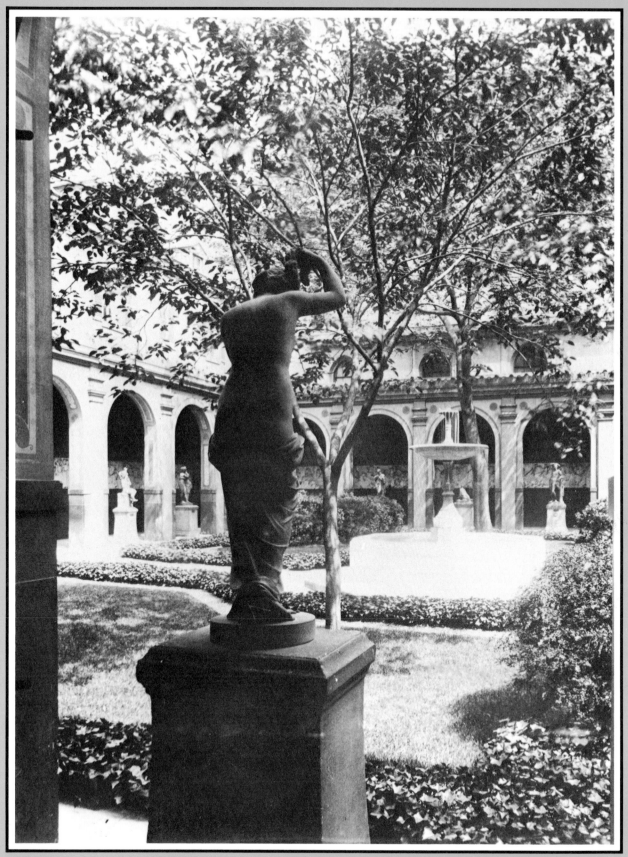

Figure 74

Figure 75

Figure 76

Notes on the Photographs

Because Atget's titles are usually quite general, more specific designation has been given by the author in most instances.

Frontispiece: **Versailles—Vase**

Vases in marble and lead after the antique were everywhere at Versailles. Like sculpture and water, they were important in providing a variety of focal points and relieving the overwhelming monotony of the vast, symmetrical design of the formal garden. The face of the sun appears with the laurel branches, palms, and rams' heads on the side of the splendid creation by Jules Dugoullons, executed in 1684–88. The Fontaine de Latone can be seen at the lower right.

From the original negative in the collection of the Caisse Nationale des Monuments Historiques

1 • **Versailles—Parterre du Nord**

Jules Hardouin-Mansart's garden façade of the palace was photographed many times by Atget, but this view, with its ominous cloud line hovering as if to announce a cosmic event, must be counted as one of his masterpieces. The new stone ornaments above the balustrade across the front of the palace roof have been restored, but the work along the side has not yet been completed.

Collection of the Lunn Gallery

2 • **Versailles—Vénus Pudigue**

Antoine Coysevox's *Vénus* views the garden façade from the terrace and steps leading to the Parterre du Nord. The original bronze was cast by the Keller brothers in 1686 but was later moved to the Louvre. The present cast was once at Marly and was brought to Versailles in 1873. Atget found the sensual form of the back either in the flesh as in his early series of prostitute portraits or in bronze or marble quite irresistible. Venus with the light defining her appealing curves was no exception.

From the original negative in the Caisse Nationale des Monuments Historiques

3 • **Versailles—Tapis Vert**

Atget has placed his camera on the left side of the terrace of the Parterre d'Eau looking west down the Tapis Vert or Allée Royale to the Grand Canal beyond. The Parterre de Latone with the fountain in the center can be seen at the right. He has framed the very essence of the French formal garden with its balance of art, architecture, and nature in this photograph. André Le Nôtre's "magnificent works—so clear, so logical, so intelligent—is derived," Pierre Nolhac has written, "not merely from the mind of the single artist, but from that of a whole race." Latone, Apollo's mother, originally faced the palace but was later turned so that she could see her son, who rises in his chariot from his basin at the head of the canal.

Collection of the Victoria and Albert Museum

4 • **Versailles—Avenue**

The *Vénus de Medici,* copied from the antique by Monnier, is poised on the north ramp of the Allée Royale leading to the Bassin d'Apollon and the canal beyond. Apollo and his horses can be seen in the distance awaiting another day.

From the original negative in the collection of the Caisse Nationale des Monuments Historiques

5 • **Versailles—Diane, ou Le Soir**

Diane as Le Soir faces the Parterre d'Eau, *"qui tient d'une main un arc et de l'autre des chiens."* It was done in 1680 by Martin Desjardins and is based on the antique figure of Diane that François I first brought from Rome to Fontainebleau in 1540. As Apollo's sister, she was a conspicuous part of the family iconography of Versailles.

Collection of André Jammes

6 • **Versailles—Allée des Trois Fontaines**

The ragged trees in off-season, the deep shadows of the conifers, the cold light against the base of the statue of Minerva, and the leaves on the rain-streaked gravel appealed to Atget's melancholy and to ours. Proust wrote that Versailles was so "aristocratic and demoralizing" that one was "not even troubled by remorse that the lives of so many workmen should have served only to refine and increase, not so much the joys of another age, as the melancholy of ours."

Collection of André Jammes

7 • Versailles—Nymphe à la Coquille

Antoine Coysevox's *Nymph with a Shell* is a pastiche of the antique and was commissioned by Mansart to join a series of sculpture placed along the avenues. The original is now in the Louvre.

From the original negative in the collection of the Caisse Nationale des Monuments Historiques

8 • Versailles—Gladiateur Mourant

The copy of the famed Roman sculpture, which is in the Capitoline Museum, was done by Michael Mosnier. The Italians first created outdoor museums in their gardens with the newly discovered antique sculpture beginning in the late fifteenth century. Pope Julius II's Belvedere garden in the Vatican held the most celebrated collection. François I, who had few originals from the antique for the garden at Fontainebleau, commissioned copies by Francesco Primaticcio in 1540, thus establishing a royal tradition of garden decoration.

Collection of Marcuse Pfeifer

9 • Versailles—Terme: Bacchus

Collection of André Jammes

10 • Versailles—Coin du Parc

The termes decorating the walks at Versailles create a virtual forest of white stone. "There is nowhere else surely such a redundancy of more or less chiseled marble," Henry James wrote. "My only complaint against this moldy mythology," he sighed, "is that it is kept in a trifle too good repair. . . . There are none of those absent arms and diminished bosoms which are so abundant in Italy."

Collection of the Lunn Gallery

• 11 • Versailles—Enlèvement de Proserpine par Pluton

The group was executed by Girardon in 1699 and triumphantly decorates the center of Jules Hardouin-Mansart's Bosquet de la Colonnade. Pluto's ardent back lifting his fragile prize in a *pas de deux,* as if posed for Atget's camera, sums up the power of Girardon's masterpiece.

Like so much of Versailles's iconography, the story of Proserpine's abduction is taken from Ovid's *Metamorphoses.* Ceres' daughter was gathering flowers in the meadows of Sicily when she was discovered by Pluto, the king of the underworld. The bas-relief on the base shows Pluto's chariot driven by Love carrying off the hapless Proserpine to become the queen of the Infernal regions.

> ". . . so, in one moment, or almost one,
> She was seen, and loved, and taken in Pluto's rush of love.
> She called her mother, her comrades, but more often for her mother.
> Where he had torn the garment from her shoulder,
> The loosened flowers fell,
> And she, poor darling, in simple innocence,
> Grieved as much for them as for her other loss. . . ."
>
> *Metamorphoses,* translated by Rolfe Humphries

Collection of the Art Institute of Chicago

12 • Versailles—Bosquet de la Colonnade

The Bosquet de la Colonnade by Jules Hardouin-Mansart may have been inspired by an illustration in the early Italian Renaissance novel *Le Songe de Polyphile.* The marble is turquoise, rose, violet, and white. Atget's photograph brilliantly explores the composition of the circular structure. It was built for theatrical presentations and other garden entertainments. Beneath each arch is a white marble vase from which a straight jet of water rises and falls overflowing the vase. The building appears to float on the sheet of water spilled from the fountains into the encircling trough.

Gernsheim Collection, Humanities Research Center, University of Texas at Austin

13 • Versailles—Les Éléments: Le Feu

Fire was executed by Nicolas Dossier in 1681 as one of the four elements. In 1674 Charles Le Brun had set out the design program for sculpture to decorate the garden consisting of six groups: the four elements, the four seasons, the four parts of the world, the four parts of the day, the four temperaments of man, and the four themes of poetry. The allegories were to follow Ripa's mythography in *L'Iconologie.*

Collection of the Gilman Paper Company

14 • Versailles—La Rivière le Loiret

Executed by Thomas Regnauldin, the bronze was cast by the Keller brothers for the Parterre d'Eau in 1689. Atget understood the qualities of sculpture and was a master of the difficult art of recording its palpable surface *patinée par le temps.* The grace and majesty of the bronze gods and goddesses lining the edge of the still surface of the great basins in front of the palace represent a triumph in combining art with the natural elements of water, sky, and plants.

Gernsheim Collection, Humanities Research Center, University of Texas at Austin

15 • Versailles—L'Amour Tenant le Fil d'Ariane

The lead statue of Amour originally stood near the entrance of the Labyrinthe, which was dismantled in the eighteenth century. The figure was executed by Jean-Baptiste Tuby in 1673.

Collection of André Jammes

16 • Versailles—Bassin de Neptune

The basin terminates the north end of the cross-axis running from the Orangerie on the south. Though begun by Louis XIV, it was not completed until 1741 during the reign of Louis XV. Atget's innate sense of composition is seen in the rhythm of the urn's flutings, which are repeated in the trees circling the basin's edge.

Collection of the Art Institute of Chicago

17 • Versailles—Fontaine de la France Triomphante

The figures of La France, L'Espagne, and L'Empire were designed by Jean-Baptiste Tuby and completed in 1683. It was originally set off by André Le Nôtre's magnificent Bosquet de l'Arc de Triomphe, which was to disappear after the Revolution.

Collection of André Jammes

18 • Versailles—Vase

The vase was created by Jean Cornu in 1683 and stands in the Parterre de Latone. The bas-relief represents bacchanalian scenes found on the antique vases in the collection of the Villa Medici. The subtle and changing play

of light on the marble relief gave Atget an opportunity to experiment with this subject many times.

Collection of the Art Institute of Chicago

19 • **Grand Trianon**, 1905

After the enlargement of the palace of Versailles had caused the destruction of the Parterre des Fleurs, the King looked for a remote spot in the park where it could be rebuilt. Naturally, the garden needed its own architectural focus, so André Le Nôtre and Louis Le Vau, in the fall of 1669, built a little summer house called the Trianon de Procelaine on the inspiration of the King's mistress, Madame de Montespan. The original exotic blue and white porcelain folly was later replaced by the present marble structure in 1688, designed by Jules Hardouin-Mansart and Robert de Cotte. As usual, Saint-Simon recorded the etiquette of the new palace. The King's invitation to a lady to visit the Trianon Palace did not include her husband unless he was specifically named, whereas at Marly, another royal retreat, husbands were automatically included in the royal hospitality extended to wives.

Collection of the Victoria and Albert Museum

20 • **Grand Trianon—Pavillon Français**

The pavilion was built in 1750 by Gabriel as a centerpiece to the botanical gardens laid out by Louis XV. It stands between the two Trianons.

Collection of the National Gallery of Canada

21 • **Petit Trianon—Le Hameau**

In 1783 the Queen, who appreciated Richard Micque's sense of *mise en scène,* encouraged him to extend the English garden of the Petit Trianon in order to include a toy village, the *hameau.* Rustic buildings, real or fake, were nothing new in French gardens, and in the spirit of the Picturesque, most had probably been adapted to garden design from earlier Flemish and Dutch paintings. George III had built a fashionable thatched cottage for Queen Charlotte at Kew as early as 1772. It was in the gardens of the Petit Trianon that the messenger found the Queen on October 5, 1789, to tell her that the mob had already left Paris and was marching to Versailles.

From the original negative in the collection of the Caisse Nationale des Monuments Historiques

22 • **Petit Trianon—Temple de l'Amor**

It was in the grounds of the Petit Trianon, Gabriel's classic pavilion, that Marie Antoinette developed the *jardin anglais.* Richard Micque, the theater designer, put up the perfect little Temple de l'Amor seen here in winter light and framed by a tree that Atget could not resist, for he photographed it many times and at different seasons.

Collection of the Victoria and Albert Museum

23 • **Grand Trianon—Fontaine**

In the intersections of the secondary avenues that crisscross the gardens of Versailles and the Grand Trianon, fountains and basins were strategically deployed. The lead cupids of the fountain can be seen in the shadows lifting up autumn's grape harvest, continuing the Apollonian theme of the seasons following the rhythm of the sun's course.

Atget used the bare trees sacked by the autumn winds to extend the

metaphor. "O mournful branches, pools and basins that a pious hand has set down here and there like funeral urns offered to the bereavement of the trees." Proust's lines read as if they had been written as a caption for this photograph.

Collection of the Gilman Paper Company

24 • **St.-Cloud—Le Champignon**

The fountain is in the center of a basin overlooking *le grand jet* to the left of the cascade. It dates from the seventeenth century.

Collection of André Jammes

25 • **St.-Cloud**

This is one of Atget's most celebrated garden photographs. In the nineteenth century, sculpture from other royal domains, such as Marly and St.-Germain-en-Laye, were added to St.-Cloud's collection. Diane, goddess of the chase, can be seen at the left across the pool. The antique original, called *Diane à la Biche,* is in the Louvre. The château stood farther along the *allée* facing toward the basin.

Collection of André Jammes

26 • **St.-Cloud—Le Canal les 24 Jets**

The ornamental basin centered on André Le Nôtre's Tapis Vert preserves the original axis laid down in the seventeenth century which ran from the main wing of the château. The so-called canal surrounded the central basin.

From the original negative in the collection of the Caisse Nationale des Monuments Historiques

27, 28 • **St.-Cloud—Le Bassin du Fer à Cheval**

The entrance to Monsieur's wing stood on axis with the center of the basin which would have been to the left and out of range. Girard probably designed the *corps-de-logis* of the château as well as the surviving pool, which was originally called the Bassin des Cygnes in 1670. A similar basin also survives at Marly.

27 • *From the original negative in the collection of the Caisse Nationale des Monuments Historiques*

28 • *Collection of André Jammes*

29 • **St.-Cloud—Terrace Stairs**

The stairs on axis with central portion of original château were flanked by the Orangerie.

Collection of André Jammes

30 • **St.-Cloud**

The gardens were built on the site of the château after it was burned in 1870. It is near the original Jardin de la Colonnade.

Collection of the National Gallery of Canada.

31 • **St.-Cloud—Terrace Stairs**

It was inevitable that Atget would have recorded so many of the garden steps in the park of St.-Cloud, given his general interest in abstract architectural compositions in the landscape and the irregular sloping terrain of St.-Cloud that required so many.

Collection of André Jammes

32 • St.-Cloud—Terrace Stairs

The garden steps are based on those Bramante designed for the Cortile del Belvedere and were inspired by the antique Roman model at Palestrina. Antoine Joseph Dezallier d'Argenville's *La Théorie et la Practique du Jardinage,* published in Paris in 1709, includes plans of similar convex-concave design.

Collection of André Jammes

33 • St.-Cloud—Grande Cascade

The *grande cascade* at St.-Cloud is not only the finest work of the architect Antoine Lepautre, it is the outstanding French garden water-piece of the seventeenth century. It cannot be dated precisely, but it was probably completed during the 1660s. An apparently earlier cascade on the site has added to the confusion of historians, for visitors even in the 1640s were remarking on "the divers waterworks and unlucky contrivances to wet the spectators," according to John Evelyn. The strong rhythm of the central arches gives only the slightest hint of any reference to natural forms. Through the opening and the gushing water, the viewer has a feeling of penetrating the mysteries of the cascade itself, which are in fact well concealed.

Collection of the National Gallery of Canada

34, 35, 36, 37 • St.-Cloud—Grande Cascade

While it was modified and restored a number of times, Antoine Lepautre's cascade remains very close to the contemporary drawing by Perelle. In 1698–99 Jules Hardouin-Mansart enlarged the lower basin and connected it to another pool by a long canal. The original figures of the river-gods holding the emblem of Philippe d'Orléans, Louis XIV's younger brother, was replaced in 1730–34 by those seen in Atget's photographs. They were executed by Lambert Sigisbert Adam. An urn pouring out the water between the Seine and the Marne (which replaced the Loire in the eighteenth century, though the iconography is basically the same) has usurped Monsieur's shield.

34 • Gernsheim Collection, Humanities Research Center, University of Texas at Austin

35, 37 • From the original negatives in the collection of the Caisse Nationale des Monuments Historiques

36 • Collection of the National Gallery of Canada

38 • St.-Cloud—Grande Cascade

The stylized rock ornamentation that Antoine Lepautre used for a surface veneer in fact covers the strict symmetry of a classical French structure. The French never took up the fashionable rustication and coarse slabs of rock that Bernini had made popular in his fountains in Rome, such as the rock forms supporting the Fountain of the Four Rivers in the Piazza Navona.

From the original negative in the collection of the Caisse Nationale des Monuments Historiques

39, 40, 41, 42 • Sceaux—Allée de la Duchesse

Atget seemed to be drawn to this avenue of trees running at a right angle to the château. He photographed it at different seasons and at different times of day, exploring the light and shadow breaking through the old trees. The avenue, called the Allée de la Duchesse, was a part of André Le Nôtre's original plan for the park. Just beyond the antique statue is the *rond pont* and the beginning of the cascade that flowed into a large octagonal basin at its base. In figures 40, 41 and 42, the nineteenth-century château on the site of Colbert's original house can be dimly seen at the end of the *allée*. The *rond pont,* which Atget placed in the foreground in Figure 42, is only hinted at in the open space in front of the sculpture in Figure 39. In the seventeenth century the hornbeams planted on either side of the avenue were kept in strict geometric form as a part of the garden architecture.

39 • Collection of the National Gallery of Canada

40, 41, 42 • From the original negatives in the collection of the Caisse Nationale des Monuments Historiques

43 • Sceaux—Avenue

The stripped and poignant old trees recall in their perfect order the rules of the French formal garden brought to perfection in the seventeenth century by André Le Nôtre. "Soaring and erect within the vast offering of their branches," Proust wrote, "and yet peaceful and calm, the trees' strange and natural pose invites us with gracious murmurings to join in this life, so ancient and so young, so different from our own, of which it seems to be the mysterious reverse."

From the original negative in the collection of the Caisse Nationale des Monuments Historiques

44 • Sceaux—Pavillon de l'Aurore

The pavilion was a small garden house built by Colbert and used for intimate dinner parties and musical entertainments. From the early plans one can see that the classic little pavilion originally faced out into a vegetable garden as an Arcadian conceit, rather than being placed in an elaborate parterre. At one point in the nineteenth century, the building was converted into a restaurant.

From the original negative in the collection of the Caisse Nationale des Monuments Historiques

45 • Sceaux

The terme representing Vertumnus, or autumn, was widely used in seventeenth-century parks. A version can still be seen in the Tuileries. See Figure 54.

Collection of the Art Institute of Chicago

46 • Sceaux

The figure of *Silène à l'Enfant Dionysos* is a copy of one of the celebrated antique statues placed in the park at Versailles in the seventeenth century. There were a number of replicas, and it was a popular garden figure.

From the original negative in the collection of the Caisse Nationale des Monuments Historiques

47 • Sceaux—Castor et Pollux

The decayed figures of the twin gods, sons of Zeus, seen in Atget's view of the wrecked park at Sceaux, appear almost as old as the myth itself. They were worshipped in Sparta and Olympia, and in Rome they enjoyed special honors as the symbol of bravery and brotherly love. The sculpture is based on the work of Coysevox executed in 1712 from the antique for the gardens of Versailles.

From an original negative in the collection of the Caisse Nationale des Monuments Historiques

48 · Sceaux—Apollon et Daphne

Throughout much of the nineteenth century and early twentieth centuries the vast park of Sceaux was leased out for various commercial operations. The muddy ruts running past Daphne and her lover, Apollo, in the once elegant corner of the park were probably made by logging wagons. The headless Daphne is seen in Atget's view to be in an advanced stage of metamorphosis.

> Her arms were branches, and her speedy feet
> Rooted and held, and her head became a tree top.
> Everything gone except her graces,
> Her shining Apollo loved her still. . . .

Metamorphoses, translated by Rolfe Humphries

From the original negative in the collection of the Caisse Nationale des Monuments Historiques

49 · Sceaux—Persephone et Pluto

The impact of Versailles in every aspect of French life in the seventeenth century extended through all the arts. The ornamentation as well as the style of gardens was subjected to the overwhelming influence of the King and his artists. This explains the widespread use of the sculpture themes such as the abduction of Persephone drawn from mythology and often copied from the same Versailles models.

From the original negative in the collection of the Caisse Nationale des Monuments Historiques

50 · Sceaux—Bassin de l'Octogone

The Corot-like view overlooks the octagonal basin at the bottom of the cascade.

From the original negative in the collection of the Caisse Nationale des Monuments Historiques

51, 52 · Sceaux—Allée de la Duchesse

The wild flowers just behind the vase in Figure 52 indicate that the time is early spring although the trees are winter-bare. The tree that leans sharply into the avenue at the left can also be seen in Figure 41.

From the original negative in the collection of the Caisse Nationale des Monuments Historiques

53 · Tuileries—Place du Carrousel

Atget has positioned his camera just in front of the site of the old Tuileries Palace (destroyed by the Commune in 1871) looking back toward the Louvre. The Arc de Triomphe du Carrousel on the right was erected in 1806 by Napoleon's architects, Charles Percier and Pierre Fontaine, to commemorate the military victories of 1805. It is based on the design of the arch of Septimus Severus at Rome. The ballet movement of the sculpture on the left heightens the feeling of theater so often found in Atget's compositions.

Collection of the Musée Carnavalet

54 · Tuileries—Vertumnus

The mask of Vertumnus that he holds in his hand seems more lifelike than the strangely lit face of the satyr as he reveals himself to Pomona, the nymph who took care of gardens, her only love and passion. Disguised as an old woman, he had just told Pomona that she was the satyr's

> first and last and only love, but . . .the story
> Had no effect, and his disguise was worthless.
> He put off woman's garb, and stood before her
> In the light of his own radiance, as the sun
> Breaks through the clouds against all opposition.
> Ready for force, he found no need; Pomona
> Was taken by his beauty, and her passion answered his own.

Atget has imbued the white marble with the bright light of Ovid's lines as if guided by their memory.

The Philadelphia Museum of Art from the Collection of Dorothy Norman

55 · Tuileries—L'Aurore by Régnier
Collection of the Musée Carnavalet

56 · Tuileries—Pavillon de Flore

The wing of the Louvre rebuilt in the nineteenth century after the Tuileries Palace was burned looms majestically above the water of the basin in the foreground. Atget knew how to manipulate water—in this case a modest pool—and its reflections to transform heavy architecture into the lightness of a desert mirage.

Collection of the Musée Carnavalet

57 · Tuileries—Apollo by Nicolas Coustou 58 · Daphne by Guillaume Coustou

The two figures stood originally on an island in the Bassin des Carpes at Marly until they were removed to the Tuileries after the Revolution. Atget made rather conventional photographs of the pair surrounded by heavy summer foliage, but he found the chill winter light and the stark trees a more appropriate setting for the sad story. Struck through bone and marrow by Cupid's fatal arrow, Apollo, wracked by incurable love, pursued the beautiful goddess.

> . . . but Daphne, frightened, left him
> With many words unsaid, and she was lovely
> Even in flight, her limbs bare in the wind,
> Her garments fluttering and her soft hair streaming,
> More beautiful than ever. . . .

But it was too late.
> . . . he ran more swiftly,
> Borne on the wings of love, gave her no rest,
> Shadowed her shoulder, breathed on her streaming hair
> Her strength was gone, worn out by the long effort
> Of the long flight, she was deathly pale. . . .

Metamorphoses, translated by Rolfe Humphries

Collection of the Musée Carnavalet

59, 60 · Tuileries—Cassandre Implorant Minerve by Rillet

In Homer Cassandra, having prophesied the destruction of Troy, had taken refuge at the altar of Minerva (whom the Greeks called Athena) to escape Ajax after the city fell. Agamemnon later rescued her and took her as his slave to Mycenae.

Collection of the Musée Carnavalet

61 · Tuileries—Retour de Chasse by Carles
Collection of the Musée Carnavalet

62 • Tuileries—Vase

Collection of the Musée Carnavalet

63 • Tuileries—Bassin

Collection of the Musée Carnavalet

64 • Luxembourg—Garden Façade

From the original negative in the collection of the Caisse Nationale des Monuments Historiques

65 • Luxembourg—Vue du Palais

Collection of André Jammes

66 • Luxembourg

The elements within Atget's well-made compositions have something of the quality of the images in a Symbolist poem. For all of their clarity there is a disturbing, mocking irony, an ambiguity that is difficult to isolate. The symbolic material here within the photograph resonates with images of art, of history, of place outside the camera's range to create a mysterious transformation of what is after all only the corner of a city park.

In the Luxembourg an ancient French queen—or is it a forgotten Orléans duchess?—stands guard beneath the naked trees. The lone figure, his black suit and hat full of implication, sits isolated on the bench in line with the military ranks of black trunks also marshaled into a subdued order of defeat. ". . . Branch by branch mark their delicate and deep despair." Proust's words echo in our memory as we look at Atget's premeditated and unrepeatable arrangement.

Collection of the Gilman Paper Company

67 • Luxembourg—Terrace

The horizontal line of the balustrade and the avenue on the left subtly frames the palace beyond.

Collection of André Jammes

68 • Luxembourg—Fontaine de Medici

The silhouette of the vase of geraniums in Atget's photograph repeats the outline of Marie de Medici's *grotte* in the background at the end of the narrow basin. The most interesting architectural decoration in the garden, it is virtually the only element to have survived from the seventeenth century, although it has been moved a number of times. The design was probably inspired by a doorway that appears in Book VI of Serlio's *Architettura*.

Collection of the Musée Carnavalet

69 • Luxembourg—Kneeling Figure

Collection of the Musée Carnavalet

70 • Arcueil—L'Aqueduc

Marie de Medici's aqueduct is a link to seventeenth-century garden history, for it carried the water to the fountains of the Queen Mother's new garden of the Luxembourg. The graceful lines of the original structure support the stark arches of the nineteenth-century additions that doubled its height. Arcueil was one of the many neglected suburbs that Atget haunted with his camera.

Collection of the Bibliothèque Nationale

71 • Paris—La Fontaine de l'Observatoire

The fountain was commissioned in 1867 as a part of the new boulevard development running south from the gardens of the Luxembourg to l'Observatoire. The general design was that of the architect Gabriel Davioud, and the sculpture was created by Jean Baptiste Carpeaux. It was completed in 1874.

Collection of the Musée Carnavalet

72, 73 • Paris—Parc Monceau

The Parc Monceau was laid out between 1773 and 1778 by Carmontelle (Louis Carrogis) for the Duc de Chartre. The *naumachie,* which Atget photographed in two parts, is one of the few original architectural elements of the garden to have survived more or less intact. The classic colonnade around the basin was built of columns that had once been a part of the unfinished Valois chapel at St.-Denis, which Catherine de Medici had commissioned. It was demolished in 1719.

The park at the time Atget knew it was the center of a smart Second Empire quarter that had been annexed to the city in 1860. The duke's elaborate gardens had become national property in 1794 and were renamed Les Folies de Chartre. They later reverted to the Orléans family but were acquired by the state in 1852 when half of the original garden was sold for subdivision.

Collection of Marcuse Pfeifer

74 • École des Beaux-Art—Courtyard

On November 12, 1920, Atget offered a main part of his collection of glass negatives to the École des Beaux-Art in a letter to the director, Paul Léon. "As I am now seventy years of age and without heirs or progeny of any kind, I am extremely anxious about this collection of plates. The possibility exists that it might fall into the hands of someone unaware of its value and that it would thus disappear without benefiting anyone." The offer was accepted with enthusiasm.

The École, the great nursery of French art and architecture housed in a group of buildings fronting on the rue Bonaparte and the quai Malaquais, was created at the time of the Revolution when the Académie de Peinture et Sculpture was united with the Académie d'Architecture.

Collection of the Musée Carnavalet

75 • Paris—Musée Carnavalet

Atget photographed the courtyard not long after the renovations and new additions to the museum were begun in 1889. The oldest part of the converted buildings devoted to the history of the city of Paris was built in 1550 by the architect Pierre Lescot. In 1660 Jules Hardouin-Mansart added a story to the original building and designed the main façade.

Collection of the Musée Carnavalet

76 • Paris—Palais Royal

In some mysterious way, Atget has managed to relate the form of the sculpture to the outline of the same tree in the background. The chaste, enclosed space reveals little of the turbulent past of the old Orléans city palace. In the Revolution of 1848, the palace was ransacked, and a huge bonfire of paintings, furniture, curtains, and even the throne of Louis Philippe was built in the middle of the garden. In 1871 the palace was again gutted by the Commune but was reconstructed between 1872 and 1876.

Collection of the Musée Carnavalet

Acknowledgements

Given Eugène Atget's extensive visual record of urban Paris, we do not immediately think of his photographs in terms of parks and gardens. For most people Atget's work evokes the *fin de siècle* city life, architecture and environment that he studied so carefully with his camera. It is this material that is most frequently reproduced and anthologized. Yet, in his views of Versailles, St.-Cloud, and Sceaux we find some of his greatest achievements as a photographer.

Since the garden photographs represent a very significant aspect of his work and have not been presented before as a group, it was difficult to limit the selection to those presented here. The generosity of those making available their collections compounded the difficulty because of the riches that were uncovered. While the Museum of Modern Art was also willing to lend from the Berenice Abbott Collection for the exhibition, their prohibition against reproduction of their prints was, of course, unacceptable. However, identical original photographs are represented in other collections and are included.

It has been a particular pleasure to work with the staff of the Service Photographique of the Caisse Nationale des Monuments Historiques and especially Alain Pougetoux whose help and energy contributed in so many ways. The unique collection of Atget's original negatives of the Caisse made it possible to fill in a small, but important number of gaps, especially of St.-Cloud and Sceaux where contemporary prints could not be located. Modern prints in these instances have been made from the negatives which Atget deposited in the public collections for that purpose. No cosmetic attempt has been made to duplicate Atget's original prints, but rather to present them simply in the spirit with which he sought to assure their honest reproduction for future generations by preserving the negatives in the archives.

Special thanks are extended to Bernard de Montgolfier, Conservateur en Chef of the Musée Carnavalet who opened up the museum's rich mine of Atget material from which many of the views of the Tuileries, the Luxembourg, and other gardens of the city of Paris were selected.

The Cabinet des Estampes of the Bibliothèque Nationale and the Department of Photographs of the Victoria and Albert Museum have also been helpful. Without the contribution of André Jammes, there would have been serious omissions. His generosity is gratefully recorded.

The inclusion of a representative selection of material from American collections was advanced with the help of Harry Lunn, Jr., whose unfailing assistance directed our attention to important sources. These include the Art Institute of Chicago, David Travis, Curator; the Gernsheim Collection, the University of Texas, Roy Flukinger, Acting Curator; the Philadelphia Museum of Art, Michael Hoffman, Curator; the Collection of the Gilman Paper Company, Pierre Apraxine, Curator; the Marcuse Pfeifer Gallery, New York; and the Lunn Gallery, Washington, D.C.

Particular thanks are due to John Harris, Keeper of the Drawings Collection of the Royal Institute of British Architects whose imagination and warm support from the outset made the whole enterprise possible. The exhibition in London has been generously funded by a gift from the H. J. Heinz II Charitable and Family Trust.

In New York, Cornell Capa, Director of the International Center of Photography, has extended the hospitality and critical support of the center for the American showing. We must also thank William Ewing, Director of Exhibitions at the Center, for his guidance in translating the exhibition for the New York presentation.

The idea for the exhibition and the present publication grew out of conversations with Patrick Bracco in connection with a shared interest in the study and documentation of the history of the French garden. Sir Francis Watson read an early draft of the text and contributed a number of useful suggestions.